The Art of
CHRISTIAN RIESE LASSEN

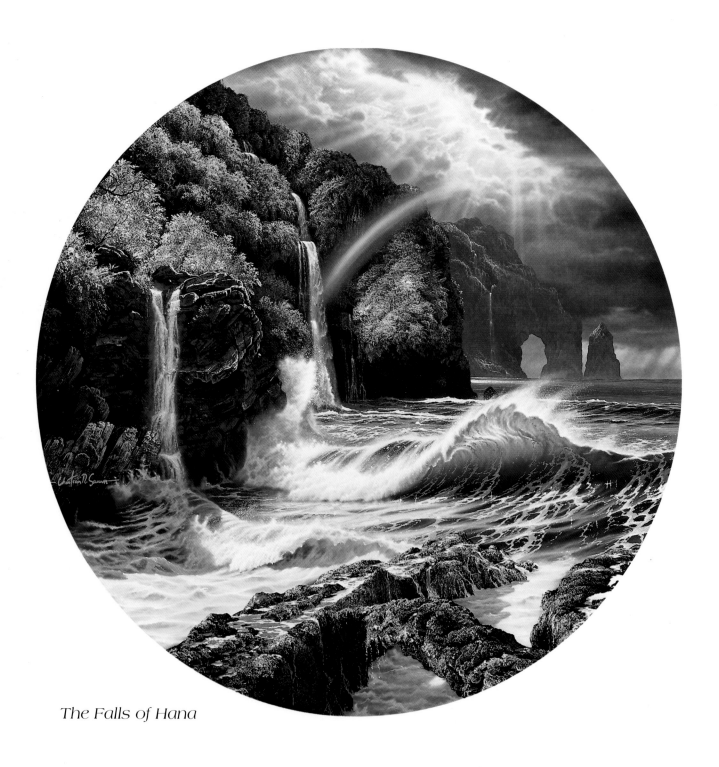

The Falls of Hana

The Art of

Christian Riese Lassen

Cedco

Cedco Publishing Company
2955 Kerner Blvd.
San Rafael, CA 94901

First Edition, January 1993
Second Edition, May 1993

This book published by Cedco Publishing Company
2955 Kerner Blvd., San Rafael, CA 94901

Printed in Korea

ISBN 1-55912-376-1

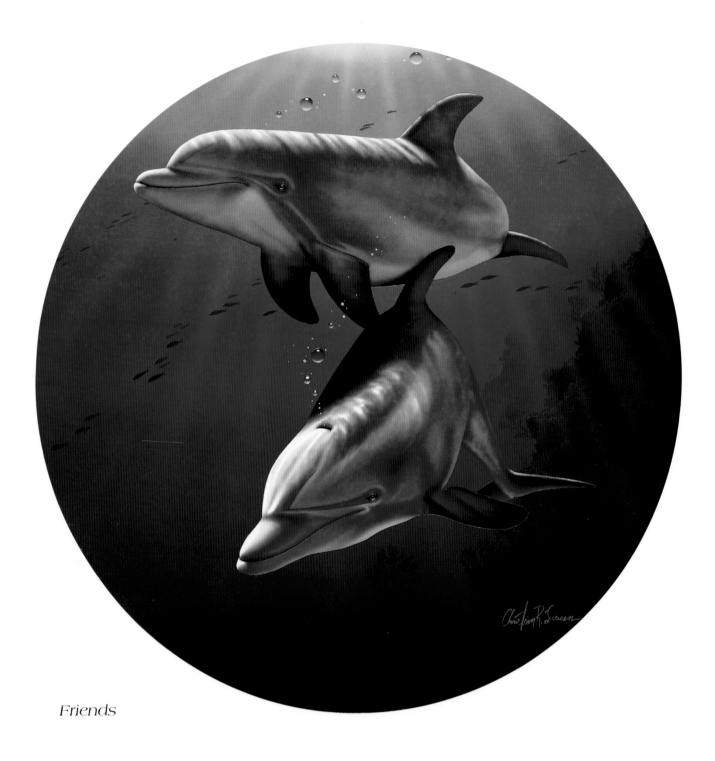

Friends

CONTENTS

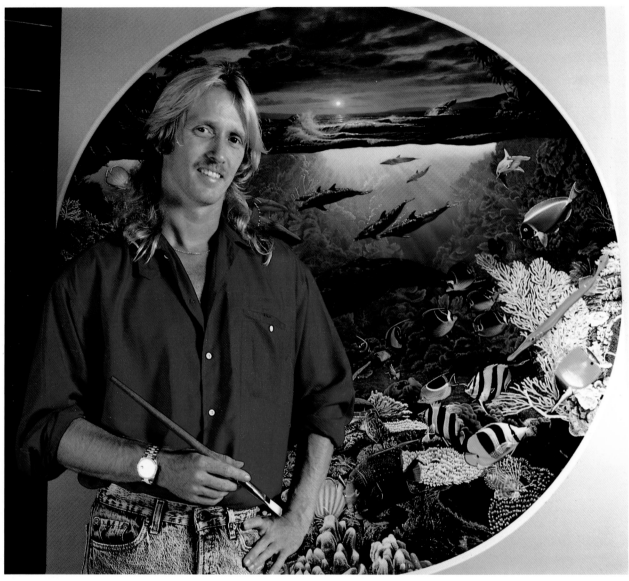

Christian Riese Lassen

INTRODUCTION

With his long blond hair and tanned good looks, Christian Riese Lassen does not match the image of "artist." Yet this 5' 10", 151 pound, young, good looking resident of Maui is one of the most successful and sought after painters of today.

Born March 11, 1956 in the small northern California coastal artists' community of Mendocino, Lassen was already expressing his artistic skills at age four. "He was born with his talent," his mother Carol notes. She remembers that his first work was a series of detailed insect illustrations. As he grew older Lassen spent endless hours sketching the living creatures in and around his home. For a change of pace he would draw pictures of the cowboys and Indians he saw on television.

When Lassen was ten, he and his family moved to the Hawaiian island of Maui; an event that would both focus his artistic skills and bring forth his second great passion, surfing. In high school Lassen's talents were sharpened by his interest in anatomical drawing. The skills he acquired were fundamental in developing his ability to depict the marine life of the islands. Lassen credits this new understanding

with allowing him to draw "...an odd-shaped creature like a whale. It's not easy," he said. "You have to understand the mammal and know where it bends to turn."

After his family moved to Maui it was no surprise that Lassen's art would focus on the ocean life of the Hawaiian islands, but Lassen's unconstrained enthusiasm for learning to surf was unexpected. In the 1970s Lassen developed from a tentative novice to a world-class competitor earning the nickname of "Slashin' Lassen" for his quick turns across the breaking waves.

After Lassen graduated from high school in 1974, he did various odd jobs such as carpet cleaning and bussing dishes to pay living expenses while he worked on his art. His first big break occurred when he became a featured artist at the Center Art Galleries in Hawaii. This exposure introduced his works to a growing circle of admirers and demand for his work grew rapidly.

To offset the pressure of trying to be "the best artist I can be," Lassen intensified his pursuit of surfing. In 1981 he augmented his skills on the surfboard by mastering sailboarding. As surfing writer Erik Aeder noted about Lassen "...his boards and sails are like flying rainbows arching across the waves, slashing white signatures on the wave faces...." As a surfer and sailboarder Lassen, the athlete, has become nearly as successful as Lassen, the artist. Over the years

Lassen's picture has been on forty-three magazine covers and he has appeared in eight movies, and an ESPN special plus numerous commercials, such as the one for SWATCH watches .

Yet the artist and athlete are connected. As Maui Gold magazine noted, "...Lassen has used his time in the water to study the movements of sea and sand, color and shadow." Many of his detailed studies of marine life show the lush life of the islands as well. These works are sharply divided by the waterline which horizontally cuts the scene. Lassen refers to these works as "multi-environmental." Each world shown is separate but just barely united briefly as when a whale breaches the surface or when an island waterfall plunges into the ocean surf. Is it coincidence that this is the surfer's viewpoint as well?

Lassen is able to create this, what he refers to as "Illusionary Realism" by using smooth plexiglas rather than textured canvas as his painting surface. Acrylic paints are used for their clean, fast-drying and non-toxic properties. Their vibrant colors and his strong brushstokes create a powerful image.

In the mid-1980s Lassen's pace of artistic creation and the recognition of his work accelerated. It was then that he established Lassen Art Publications to promote and market his works. Soon thereafter he hired Joná-Marie Price as Executive Sales Director. In the seven years since, Lassen Art Publications has grown into a multi-million dollar

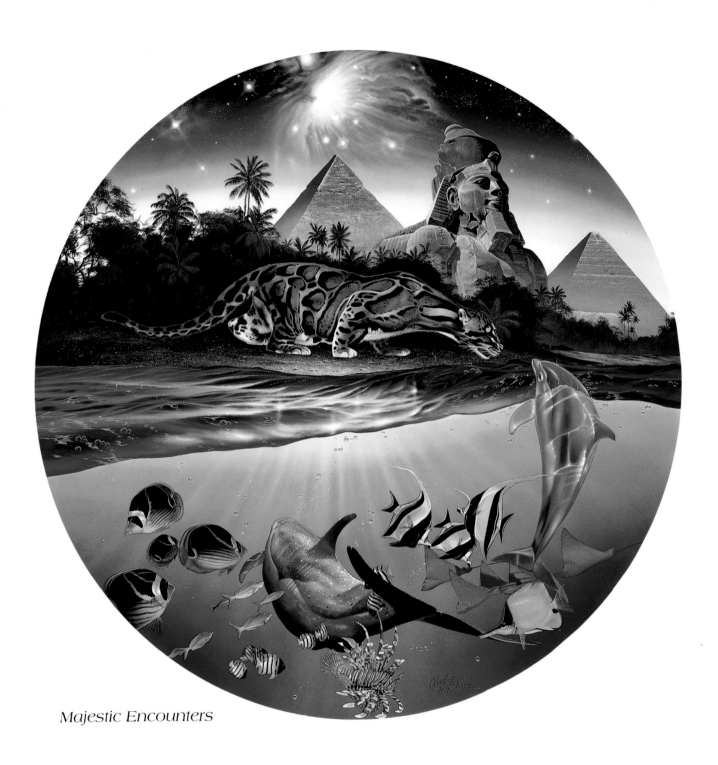

Majestic Encounters

company employing over 100 people working in three galleries, three separate offices and two large warehouses totalling approximately 10,000 square feet overseen by Price, its 28-year-old President.

In 1989 Lassen designed the official Honolulu Marathon poster and the following year the poster for the prestigious Triple Crown of Surfing championship. Nineteen ninety was a banner year for Lassen in the commercial marketing of his images worldwide. That year he signed a licensing agreement with industry giant Hallmark Properties, the world's largest producer of greeting cards. Lassen joined a select elite of outside artists licensed by Hallmark. These include Norman Rockwell, Charles Schulz and Walt Disney Productions.

In his life as well as in his paintings there is a "multi-environmental" aspect. In 1990 Lassen created the Seavision Foundation, a non-profit organization dedicated to preserving the marine environment and funded by sales of his artwork. "I feel as if I've been given a unique gift to inspire and perhaps influence people about the importance of the ocean," says Lassen. "The ocean has given so much to me. I feel it's my obligation to give something back." This "obligation" was further met by Lassen's donation of his painting "Sanctuary" to the World Federation of United Nations Associations (WFUNA). A reproduction of the painting appeared on first day covers which accompanied the release of a United Nations stamp addressed to the effort to clean the oceans, issued March 13, 1992. Posters of the original painting

were signed by Lassen and sold by the WFUNA to raise funds for this campaign.

To Lassen one of the most satisfying moments of his career was the opening of Galerie Lassen in his hometown of Lahaina on the island of Maui on July 12, 1991. The gallery building is itself a work of art, a brass, glass and marble "frame" for Lassen's works. The most striking feature is a 16-screen video wall which shows Lassen involved in his passions of painting and surfing. The gallery offers something for everyone. Fine art ranges from original paintings that sell for $200,000 to limited edition prints priced at under $1,000. And for those who value the art and the artist but come with modest funds there are note cards, jewelry, apparel, calendars and other quality gift items.

Lassen's work has a special appeal in Japan where he is now considered the most popular artist. In May of 1991 Lassen traveled with an exhibition of his own works on a tour of major Japanese cities. Thousands of his fans crowded each gallery exhibition and Lassen appeared on television and in magazine coverage of his visit as well. He also voiced his environmental concerns in Japan. In the recent "Global Citizens Meeting for the Environment" Lassen, as the featured speaker, addressed an audience of 35,000 participants.

Like the ocean, Lassen's work changes constantly at and below the surface. Trips to Europe have generated work influenced by the

scientific detail of Leonardo da Vinci and Michelangelo as well as a series of paintings that bear the unmistakable influence of the impressionists school. From his own active life Lassen has generated a brilliantly "kinetic" style of action sports painting which includes football, basketball and, of course, windsurfing. It is a new and challenging style for him. "I like the feeling of tension in my paintings...." he notes. In his underwater art he improvises as well. Recently he has begun setting small faceted gem stones into his paintings to capture brilliant highlights in a way that nothing else can.

It has been said that life imitates art. For Christian Riese Lassen the boundary is permeable, "multi-environmental." He is one moment the participant and the next the viewer. As Lassen said of his marine paintings, "They tell a story — how life interacts...." Or as writer Erik Aeder said about Lassen, "An ultimate day for him is to surf in the morning, sail in the afternoon and paint in the evening."

SEA VISIONS

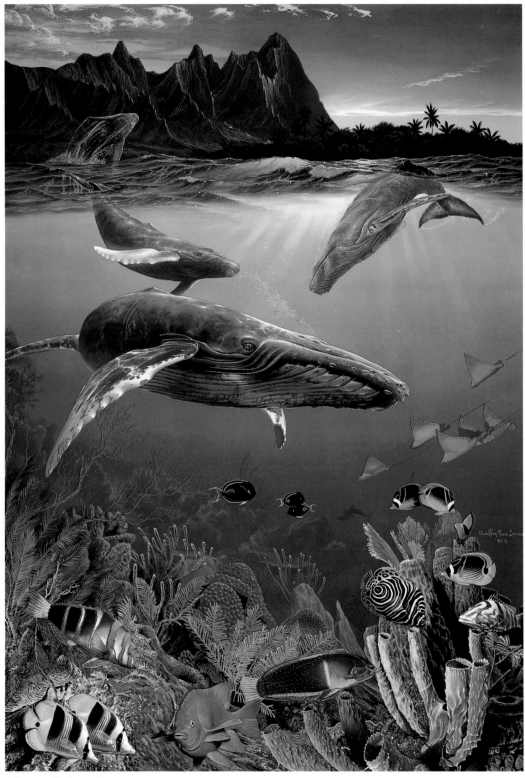

Hawaii Sea Passage

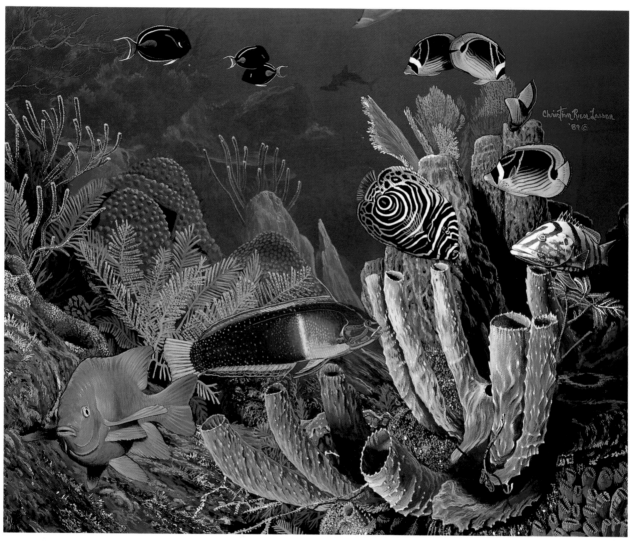

Hawaii Sea Passage (detail)

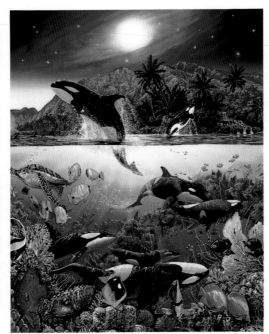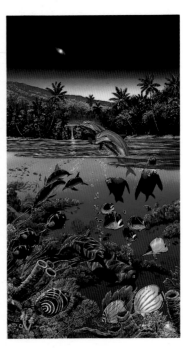

Harmony (triptych)

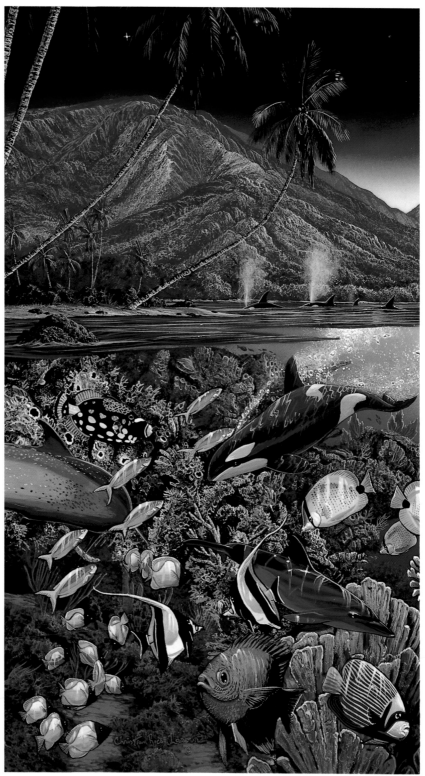

Harmony (left panel)

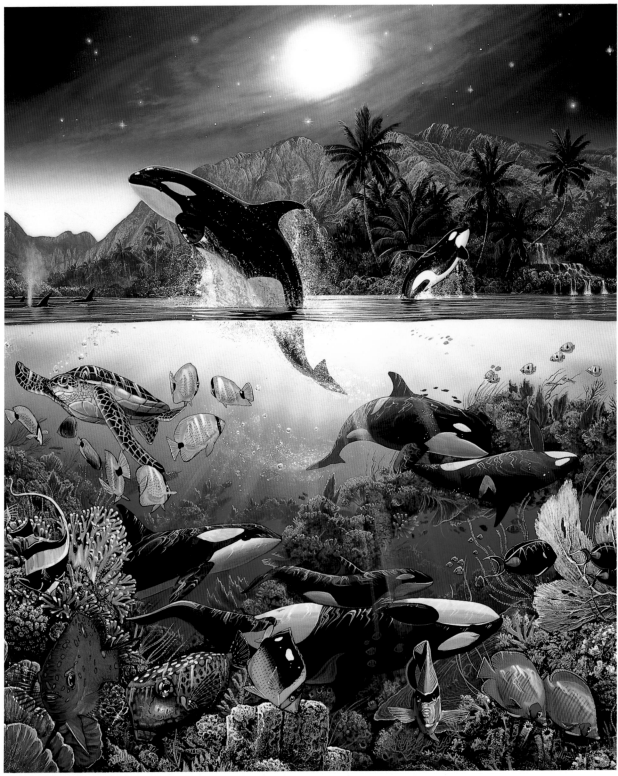

Harmony (middle panel)

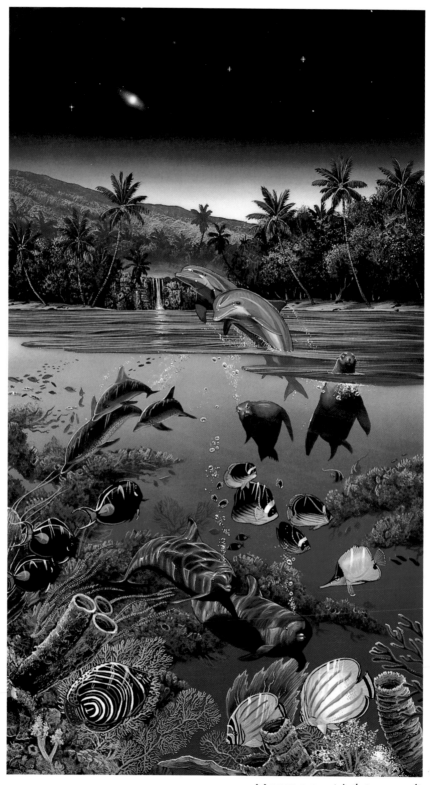

Harmony (right panel)

I liked to sail alone. The sea was the same as a girl to me—I did not want anyone else along.

E. B. WHITE

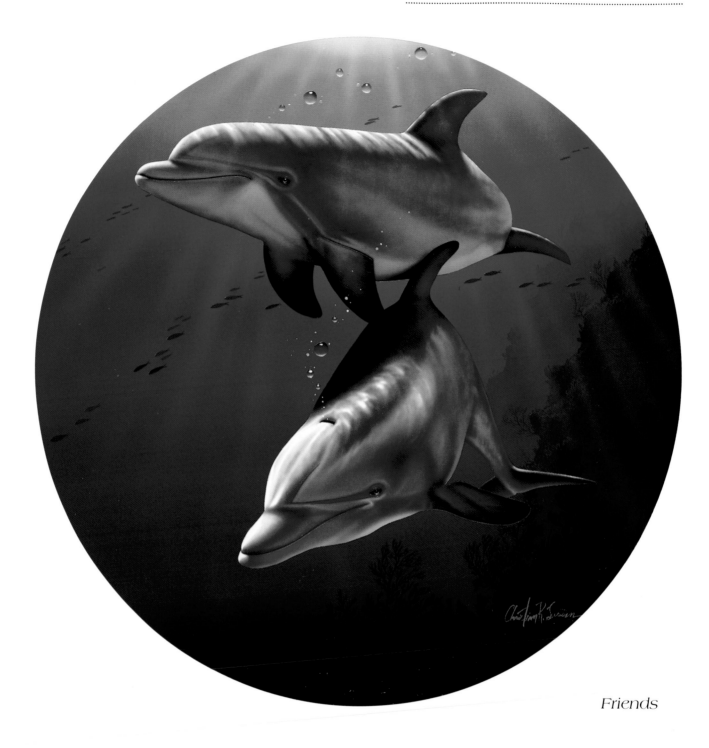

Friends

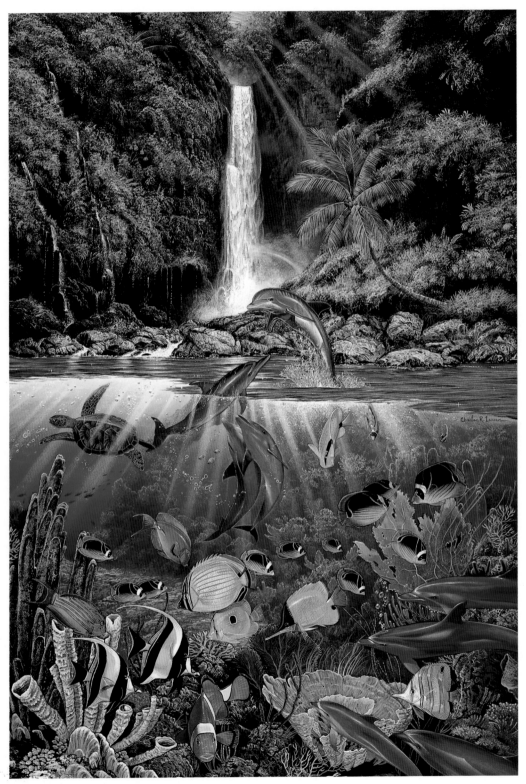

Eternal Rainbow Sea

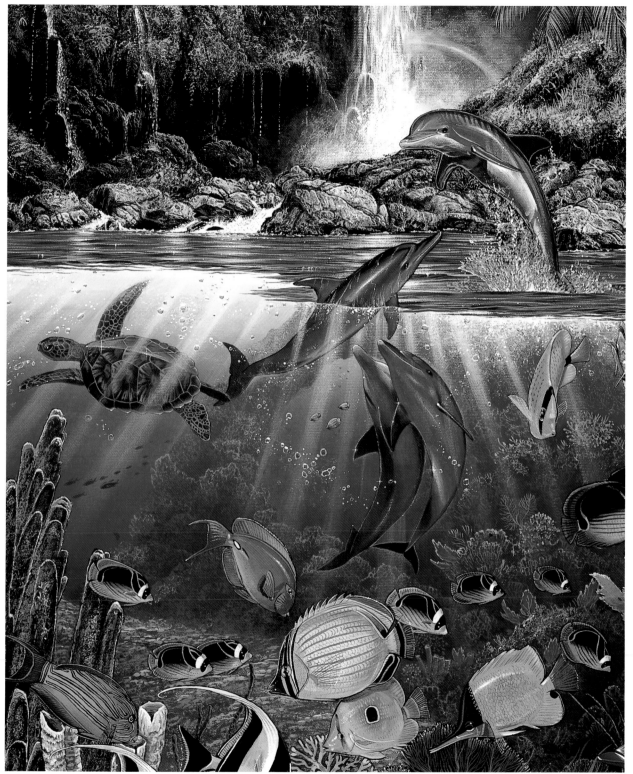

Eternal Rainbow Sea (detail)

All *the rivers run into*
the sea; yet the sea is not full.

ECCLESIASTES 1:7

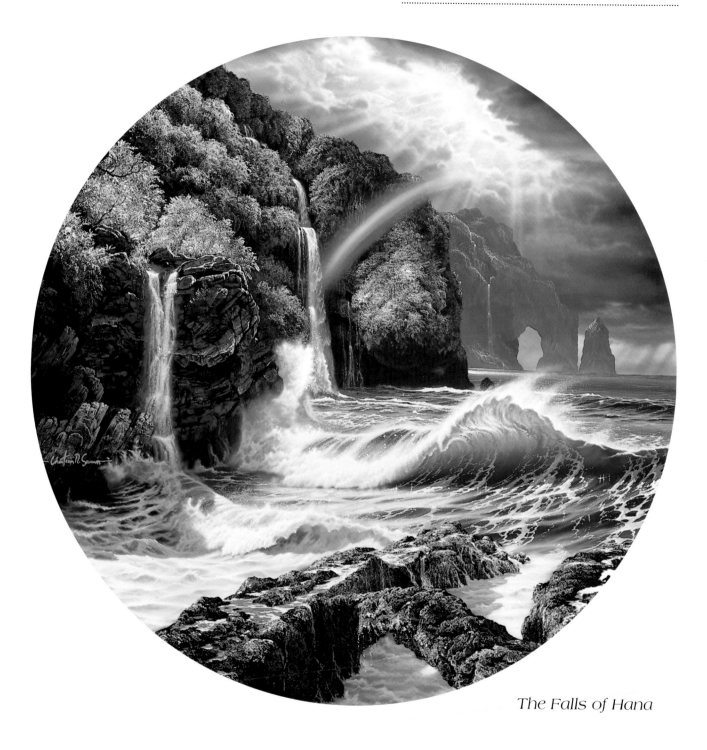

The Falls of Hana

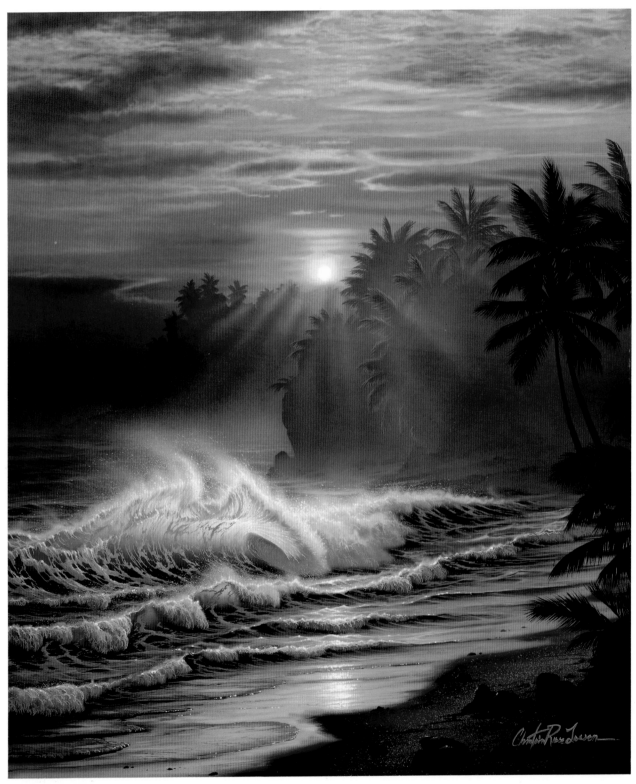

Golden Moment

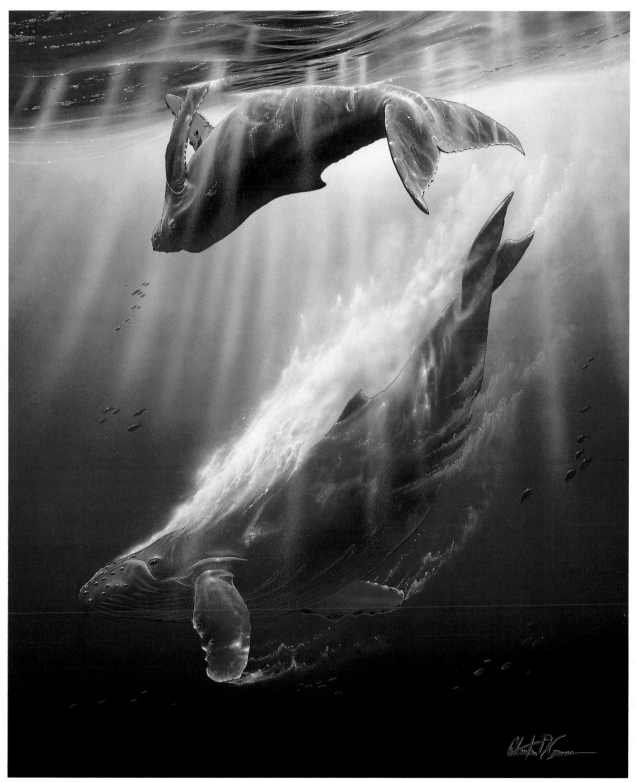

Whale Song

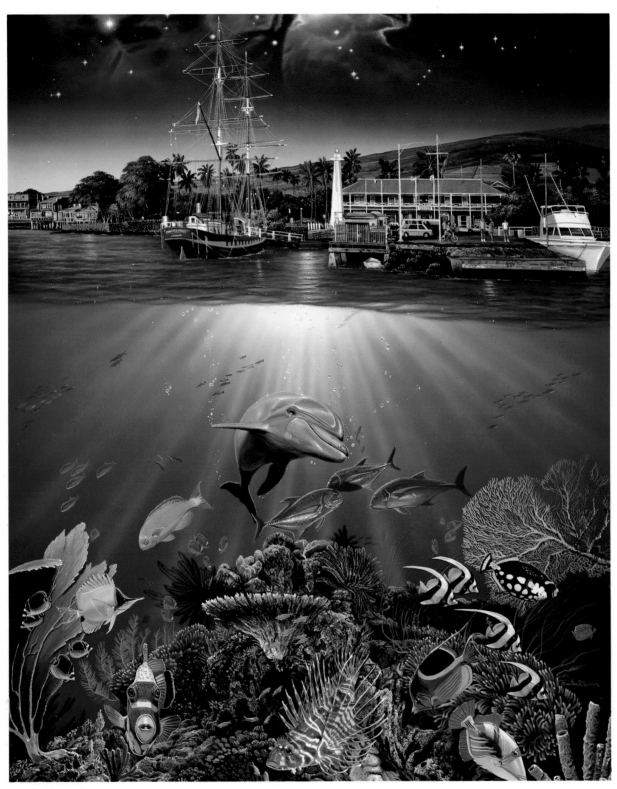

Lahaina Dreams

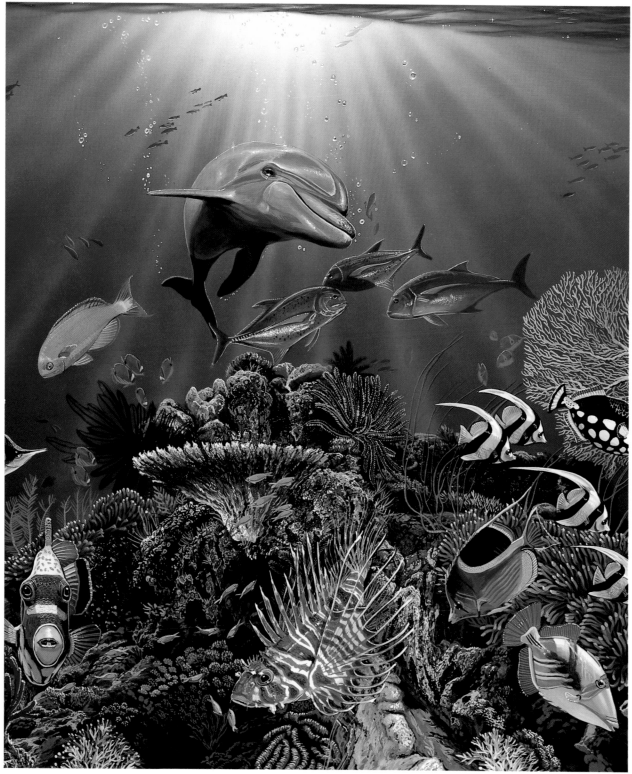

Lahaina Dreams (detail)

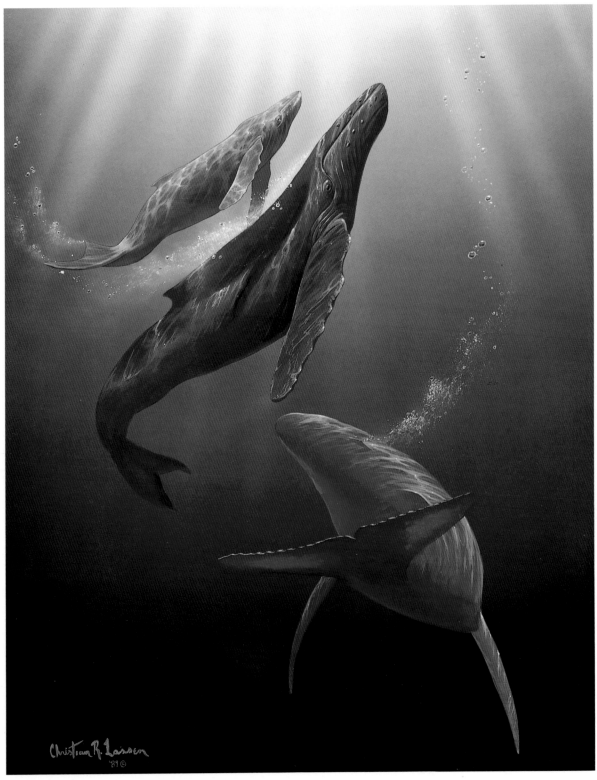

Lords of The Sea

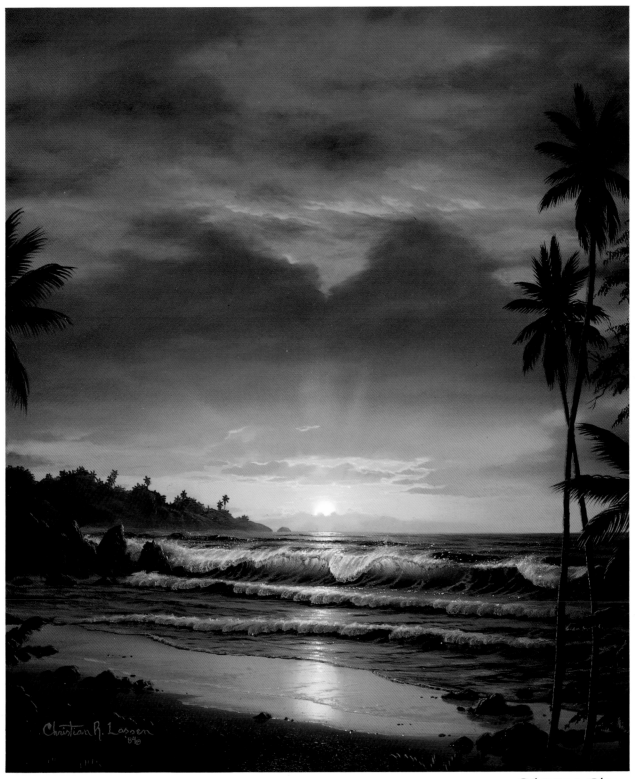

Crimson Glow

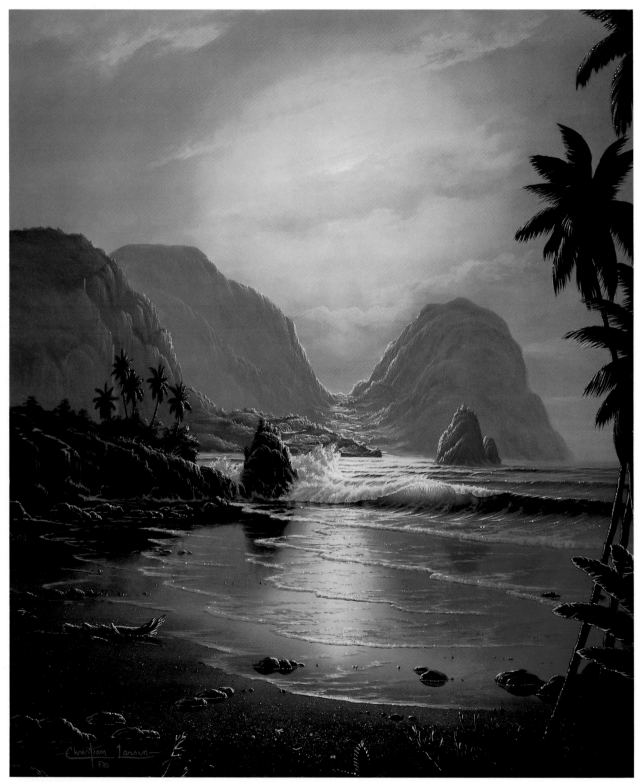

Molokai Enchantment

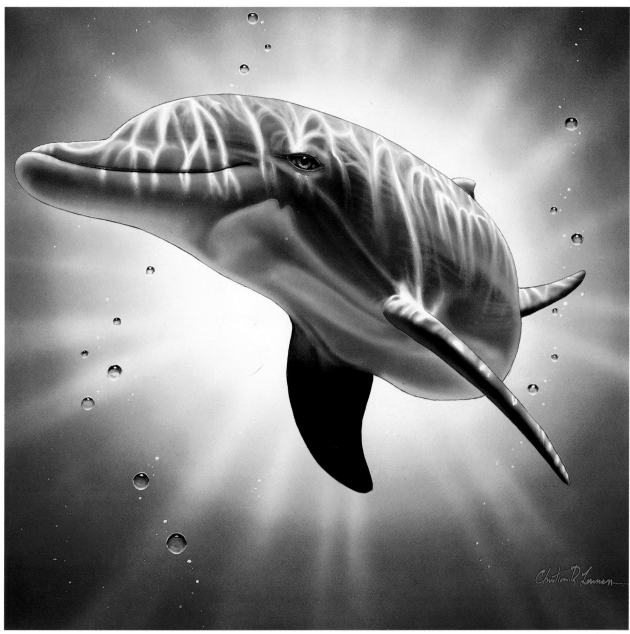

Kolohe

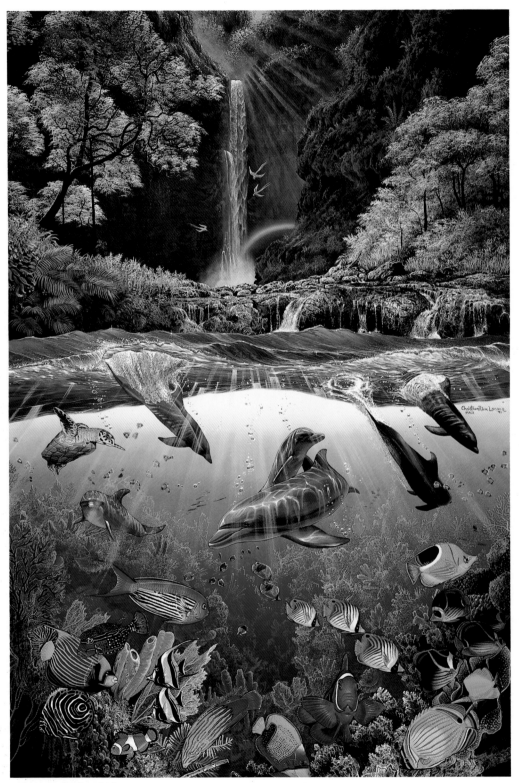

The Infinite Way

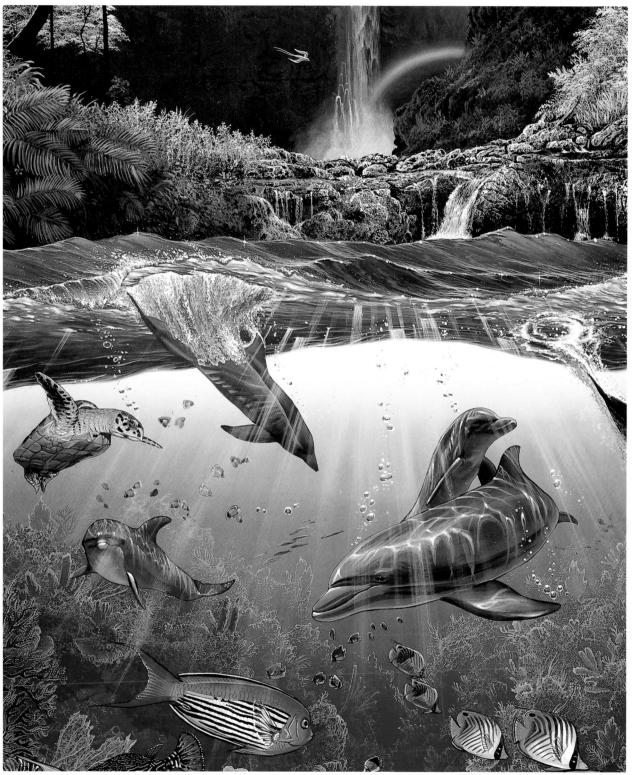

The Infinite Way (detail)

I am the daughter of Earth and Water,

And the nursling of the Sky;

I pass through the pores of the ocean

 and shores,

I change, but I cannot die.

PERCY BYSSHE SHELLEY

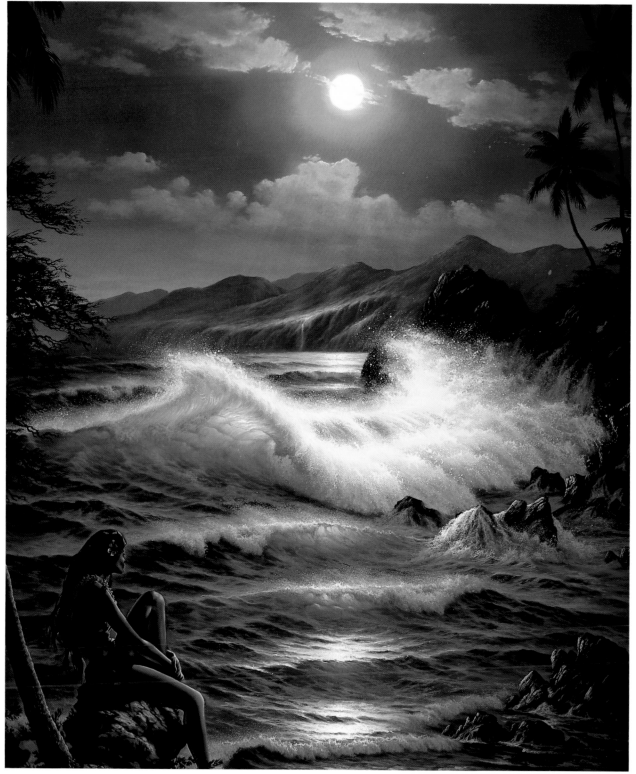

Blue Hana Moon

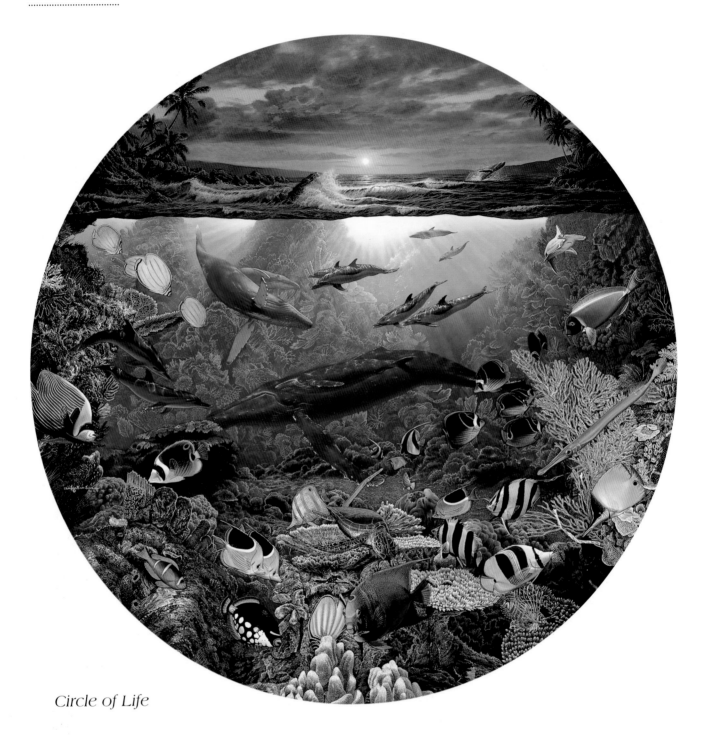

Circle of Life

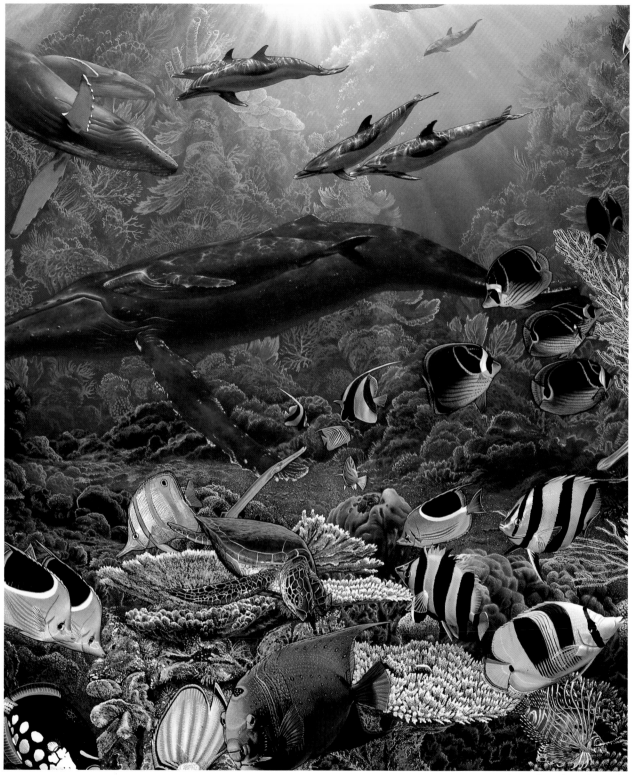

Circle of Life (detail)

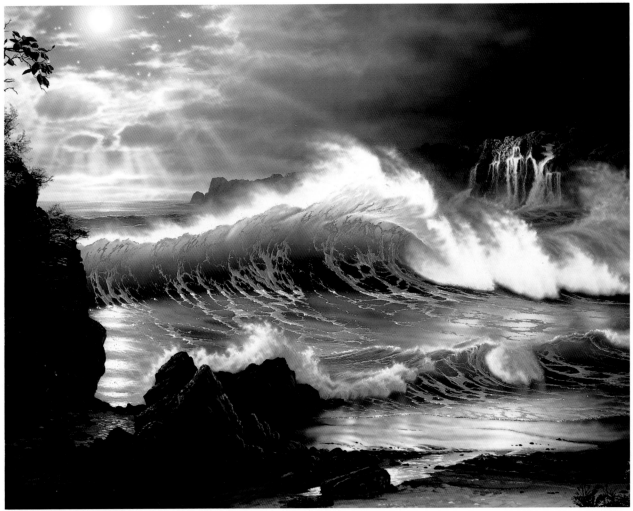

Cliffs of Kapalua

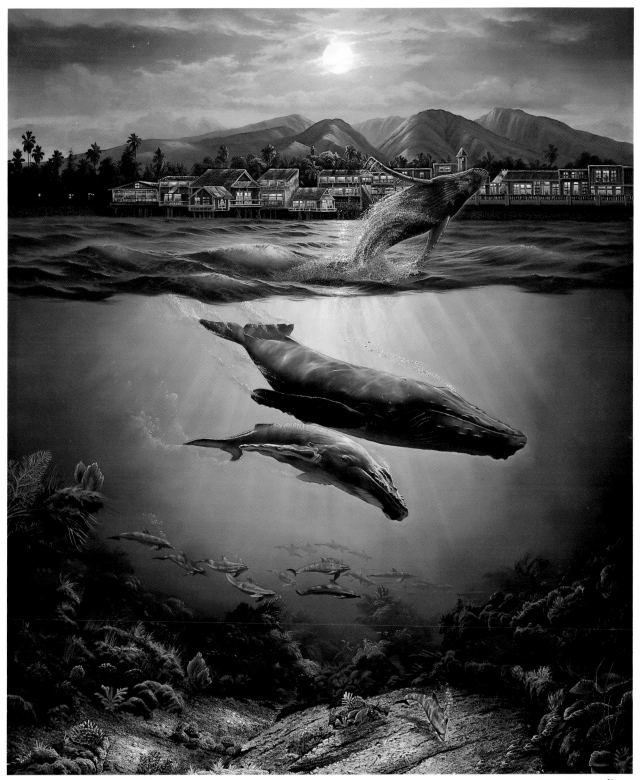

Return To Paradise

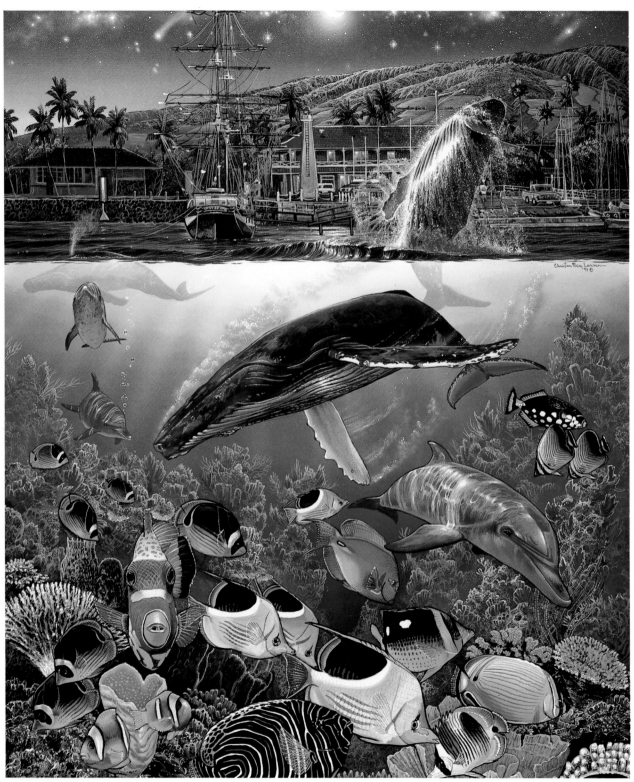

Crystal Waters of Maui

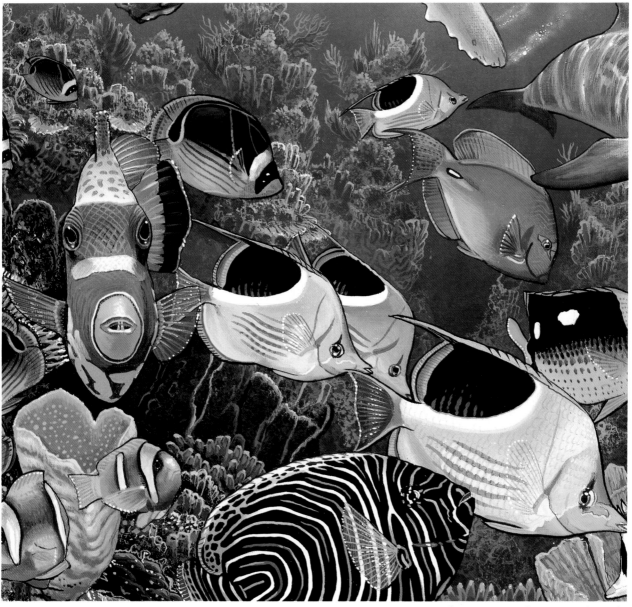

Crystal Waters of Maui (detail)

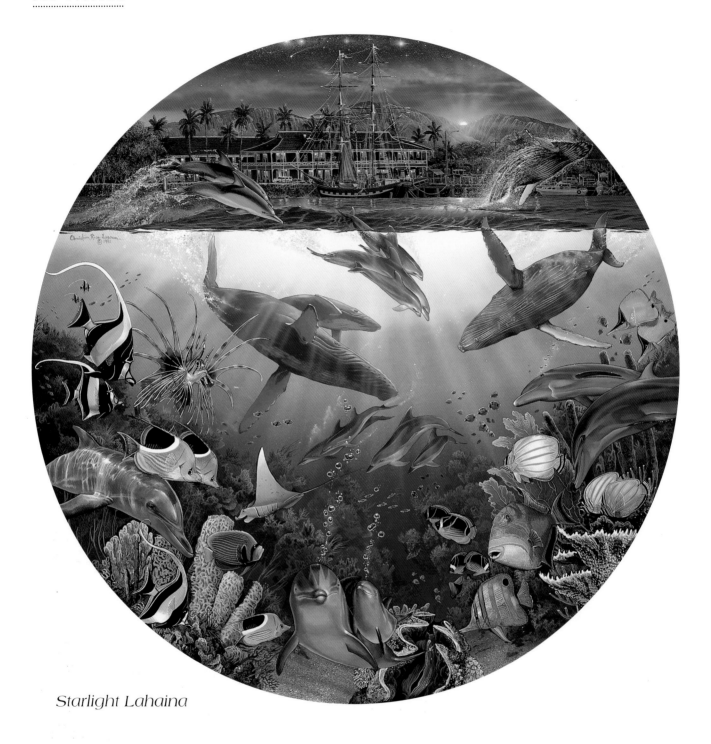

Starlight Lahaina

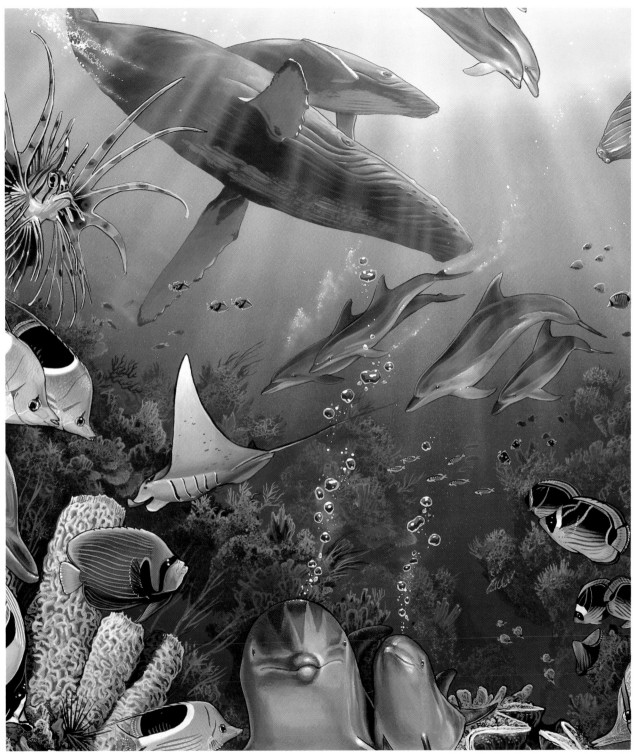

Starlight Lahaina (detail)

The fair breeze blew, the
white foam flew,
The furrows followed free;
We were the first that ever burst
Into that silent sea.

As idle as a painted ship
Upon a painted ocean.

SAMUEL TAYLOR COLERIDGE

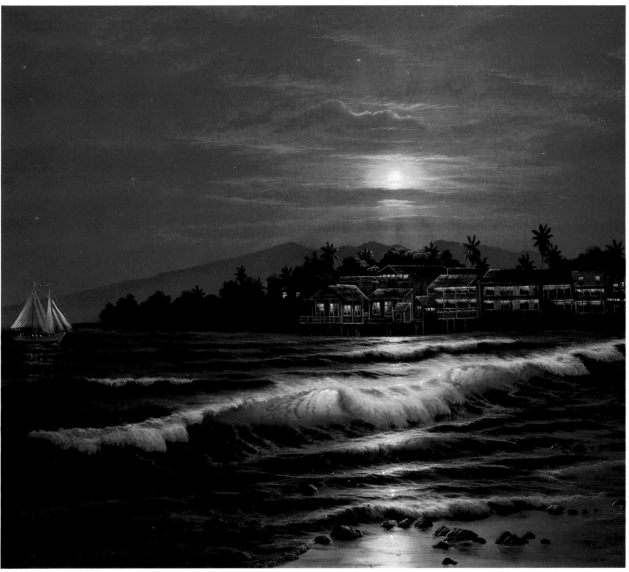

Peaceful Lahaina Eve II

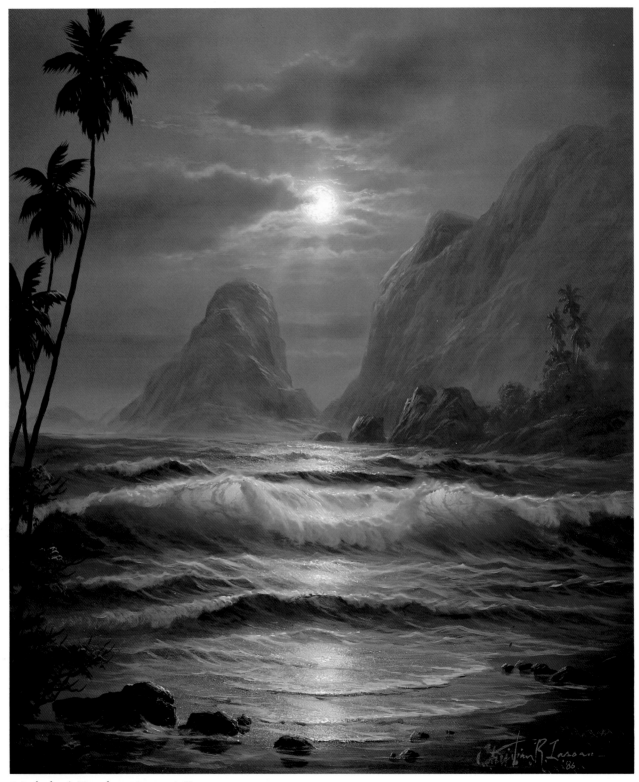

Molokai Enchantment II

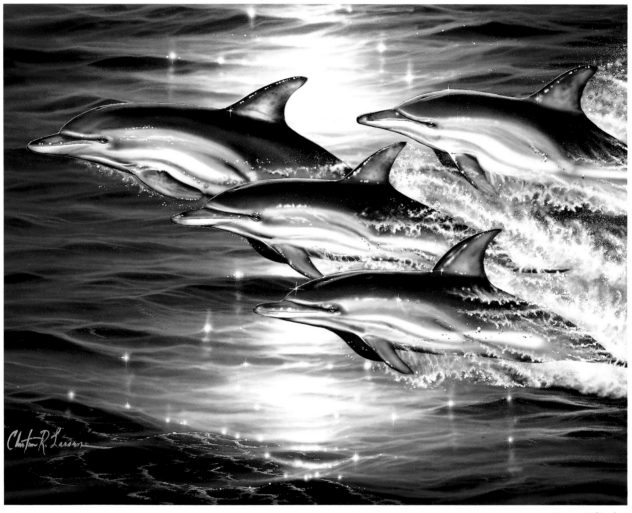

Sea Flight

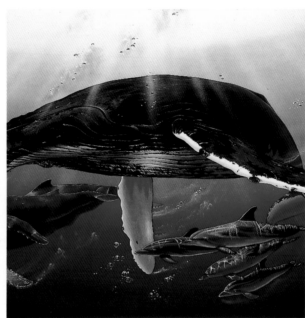

Unity (triptych)

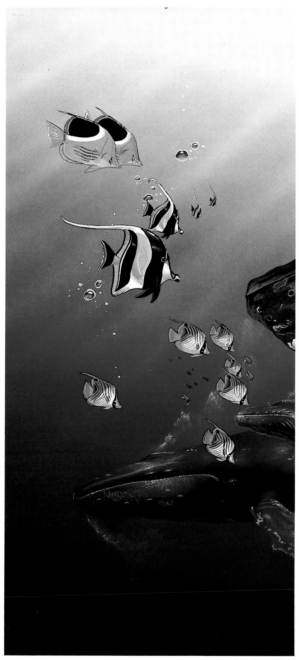

Unity (left panel)

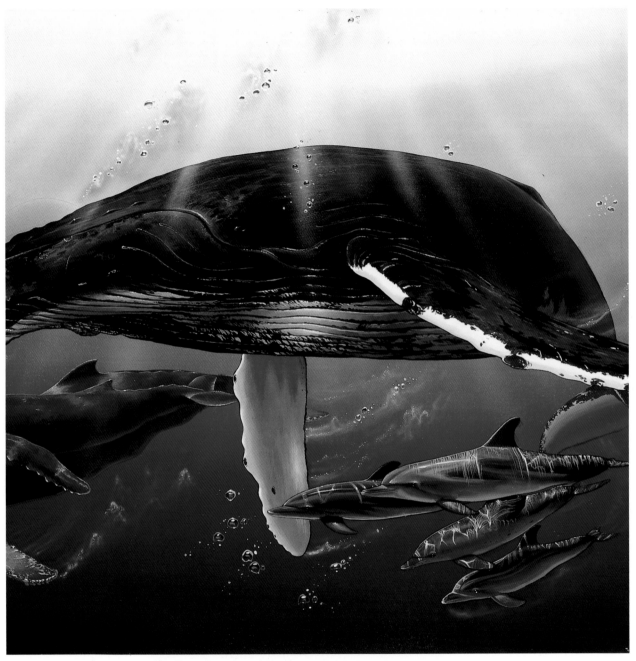

Unity (middle panel)

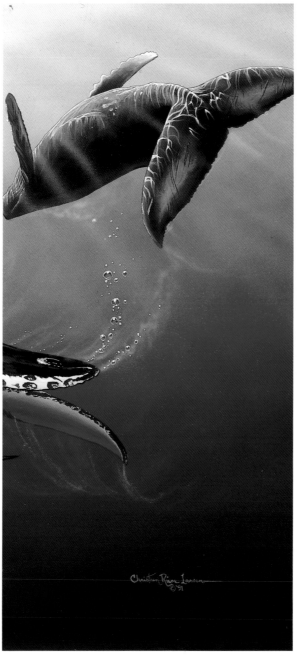

Unity (right panel)

I love the sea; she is my fellow creature.

FRANCIS QUARLES

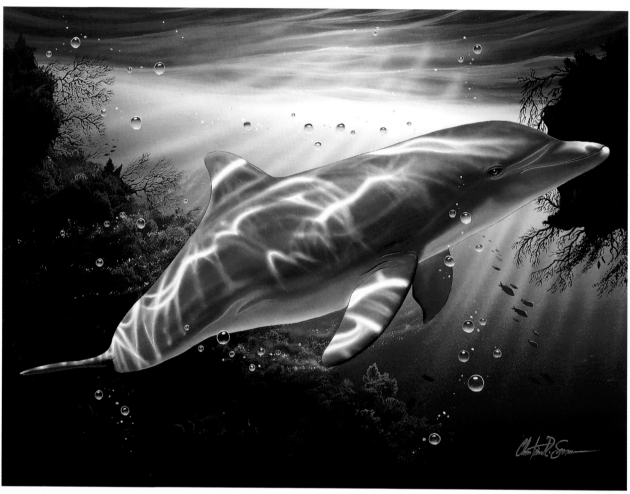

Dolphin Vision

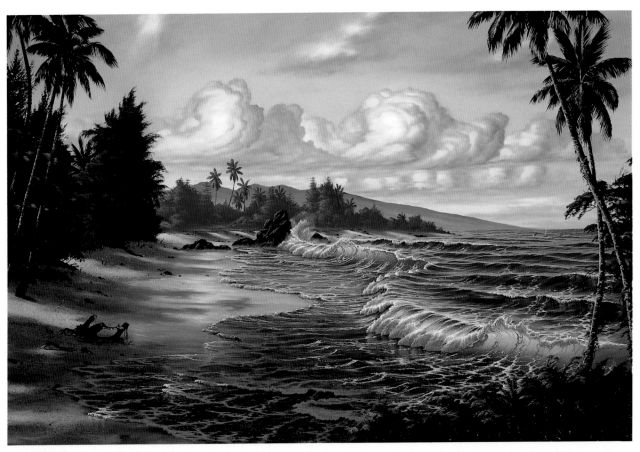

Untitled

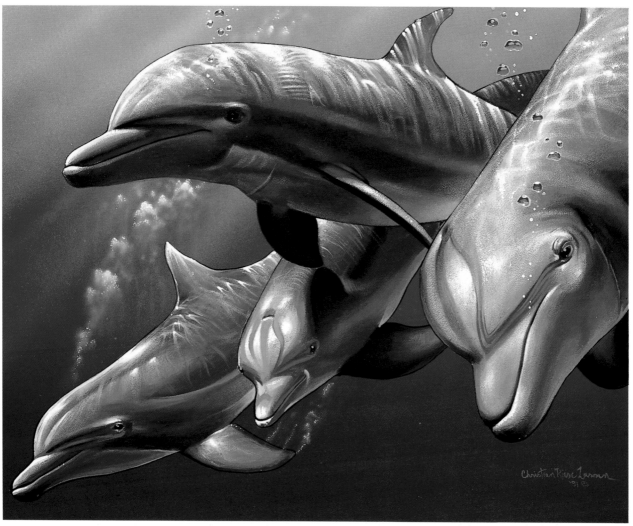

Dolphin Quest

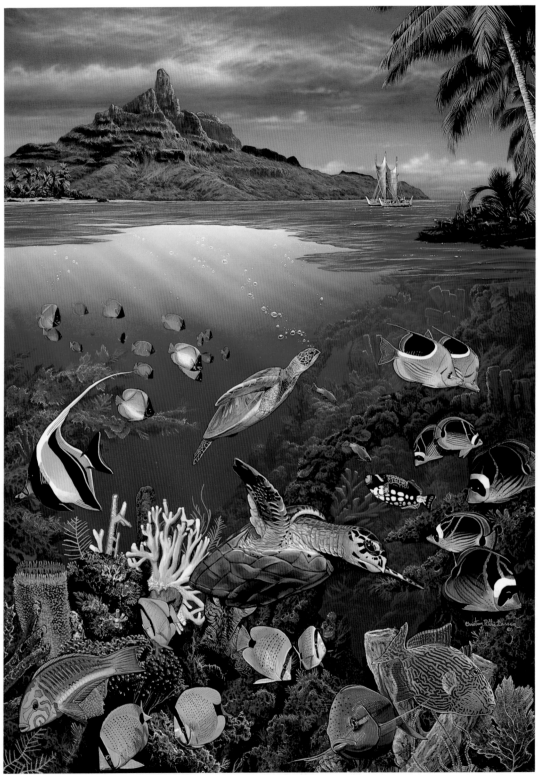

Voyage of The Ho'okulea

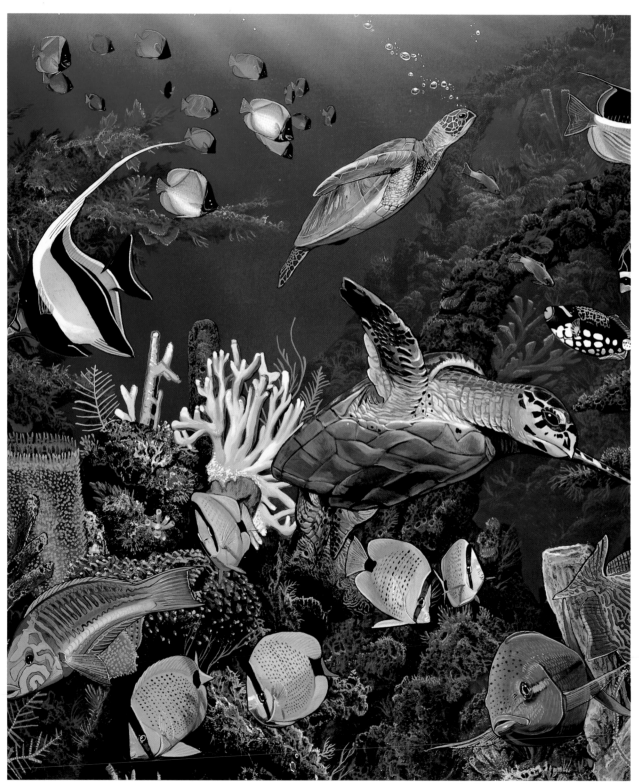

Voyage of The Ho'okulea (detail)

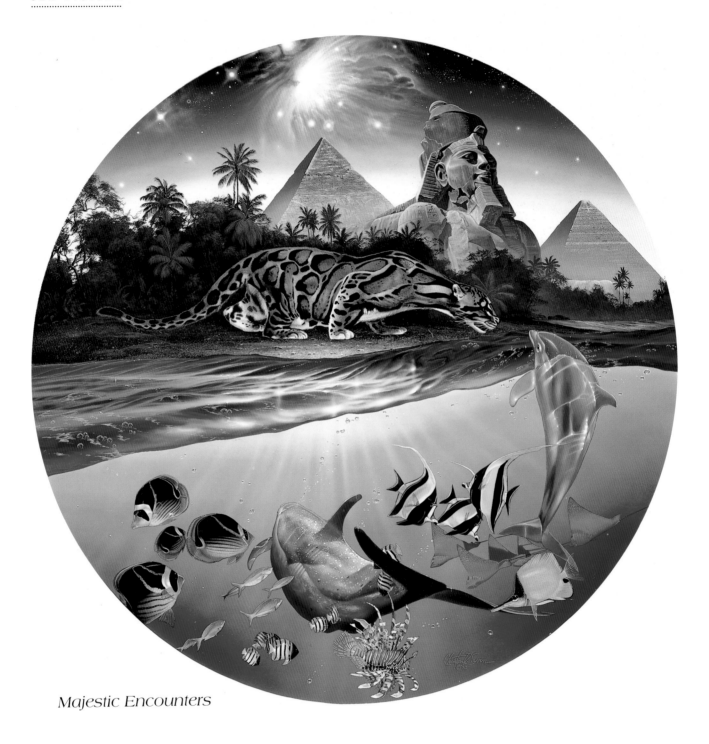

Majestic Encounters

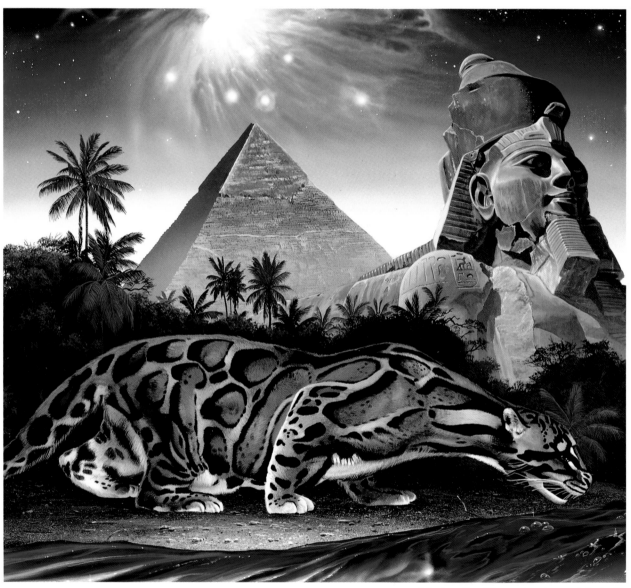

Majestic Encounters (detail)

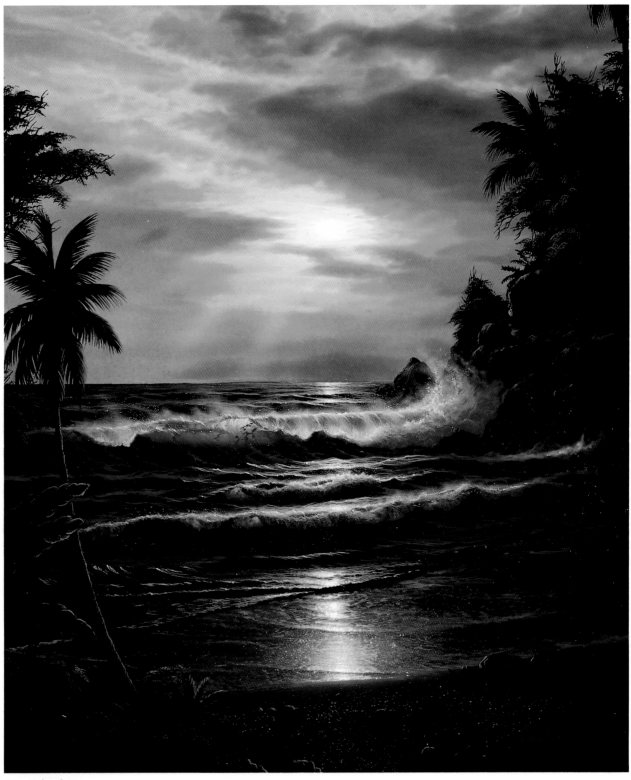

Untitled Seascape

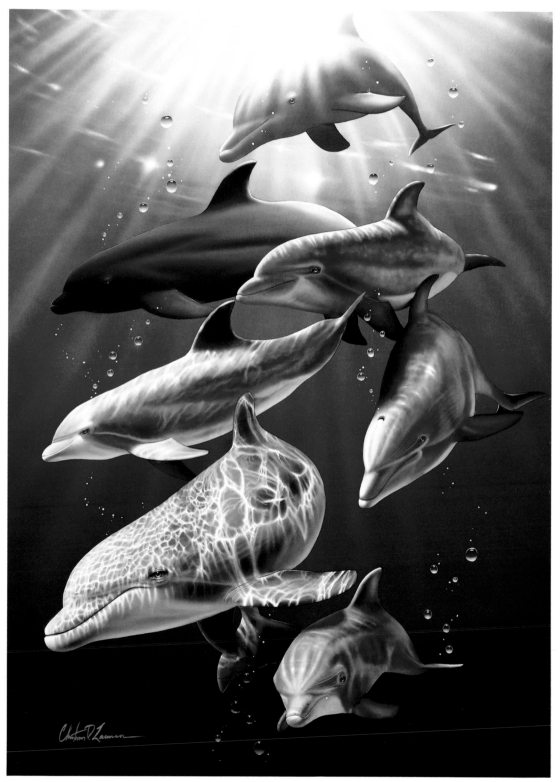

Family

—when skies are hanged and
* oceans drowned,*
the single secret will still be man.

EDWARD ESTLIN CUMMINGS

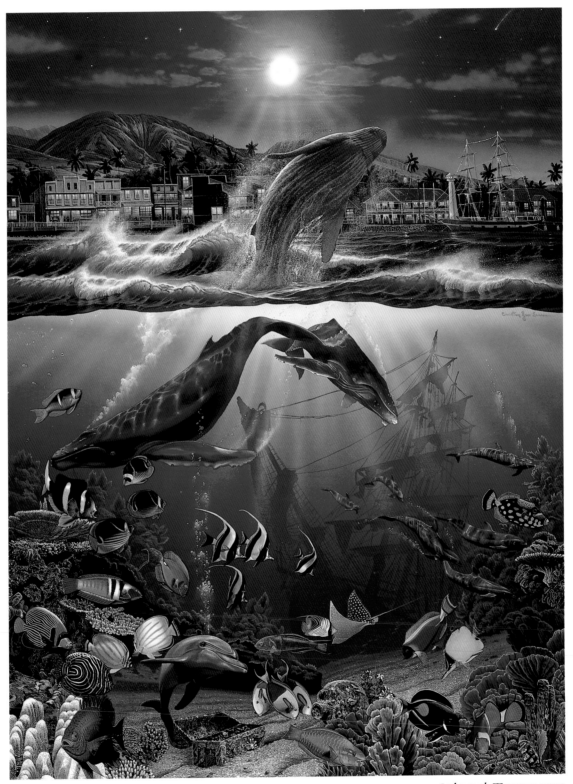

Island Treasures

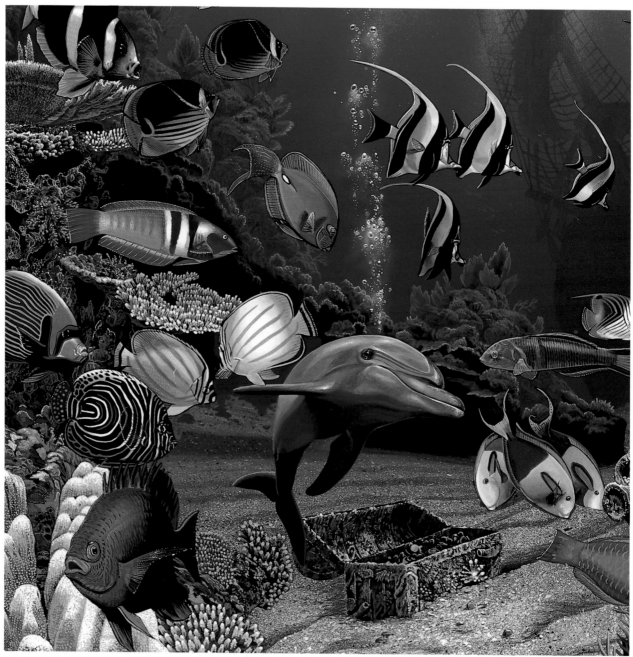

Island Treasures (detail, lower left)

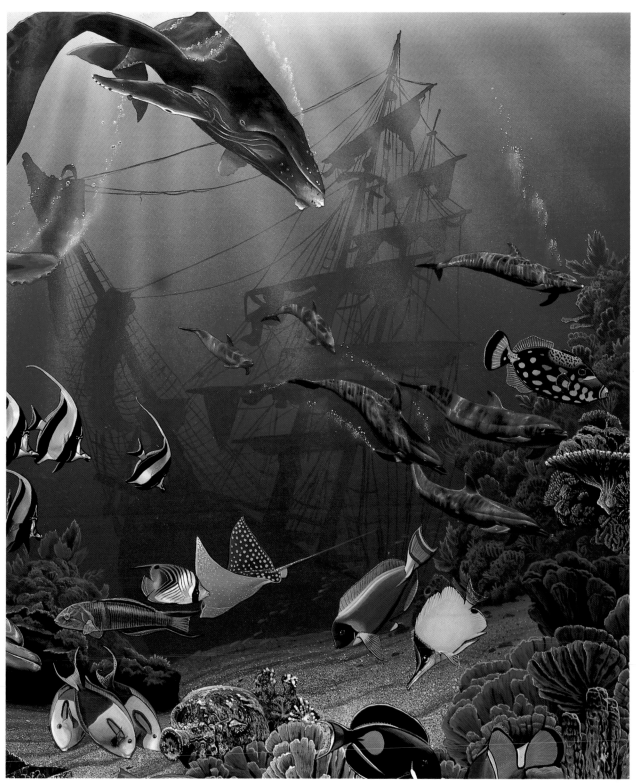

Island Treasures (detail, lower right)

MYSTIC VISIONS

Tomorrow once again we sail the Ocean Sea.

HORACE

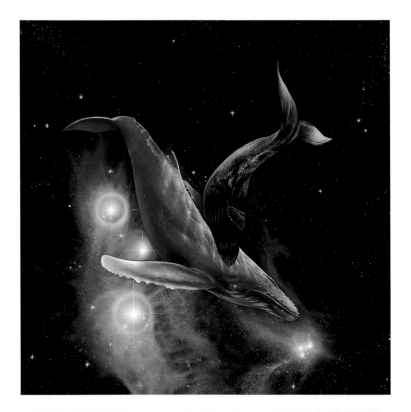

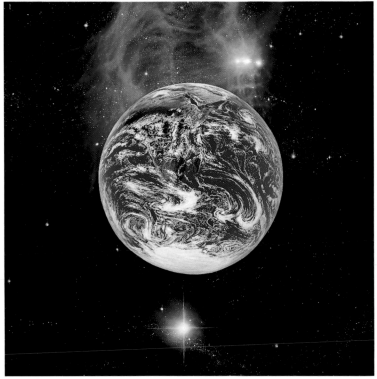

Revelations (diptych)

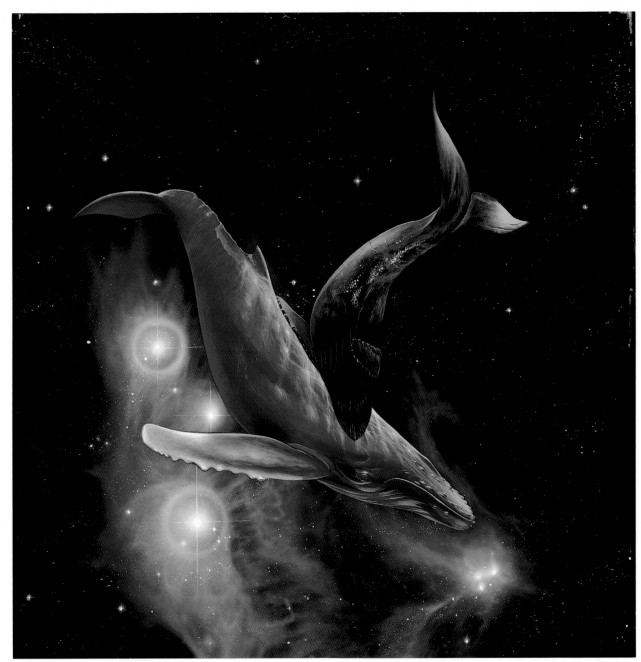

Revelations (top panel)

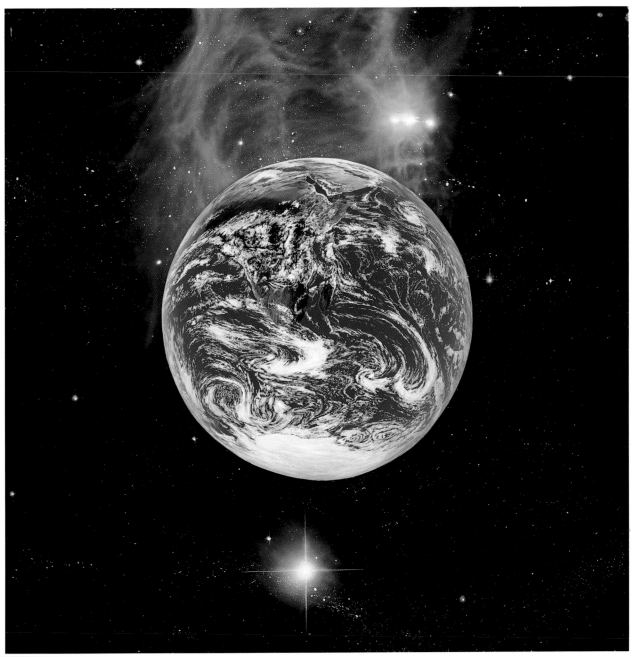

Revelations (bottom panel)

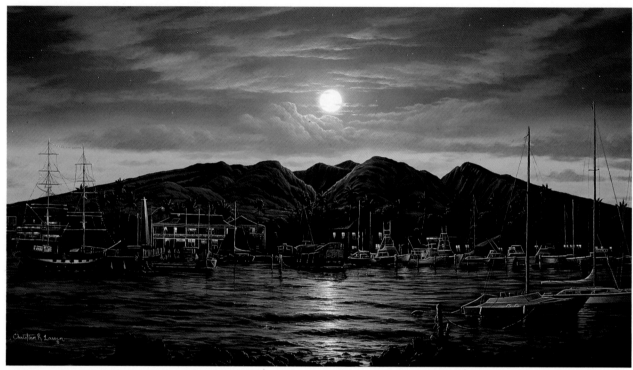

Home Port II

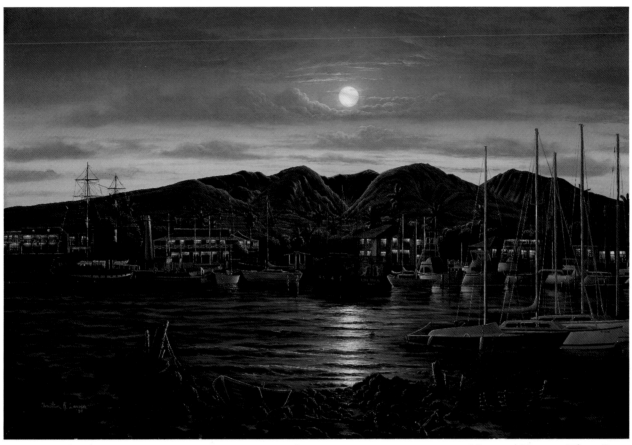

Home From The Sea

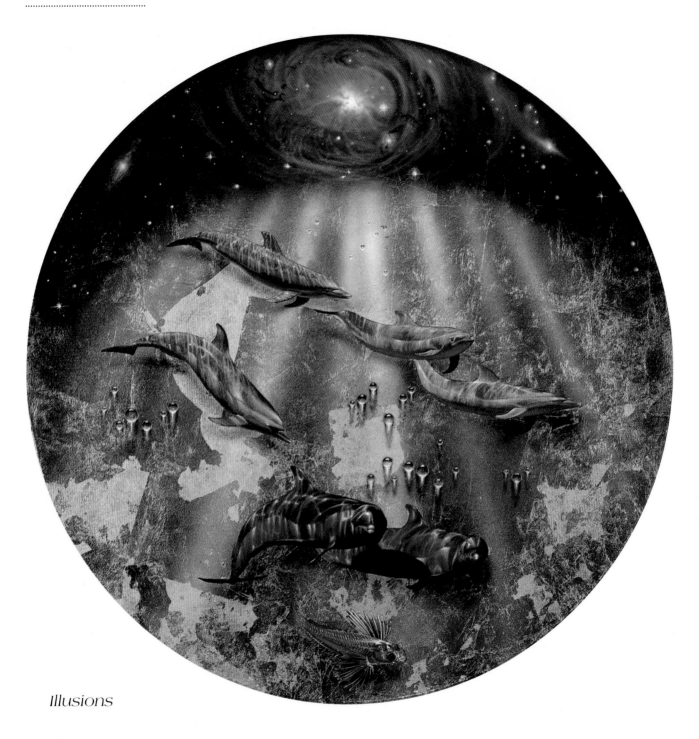

Illusions

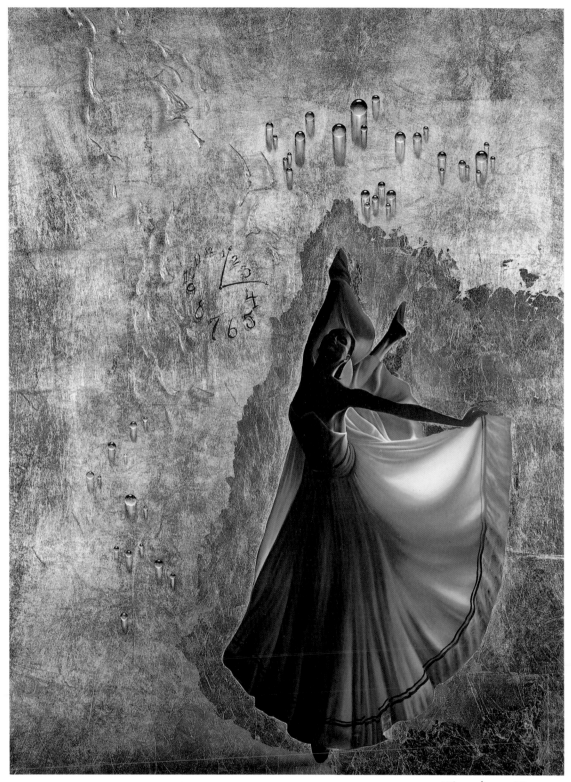

Timeless Dance

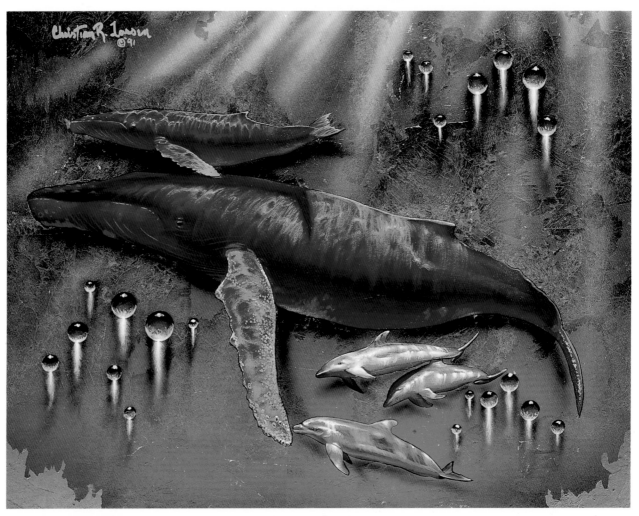

Mystic Eternity

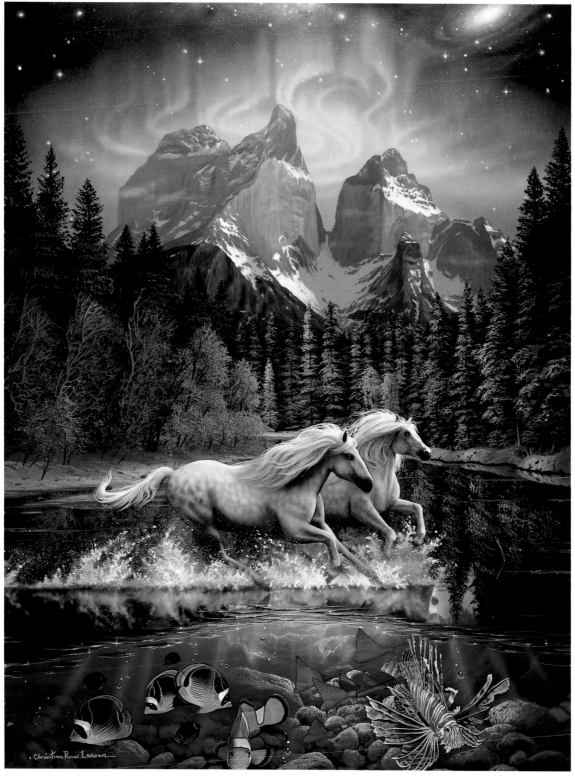

In Another World

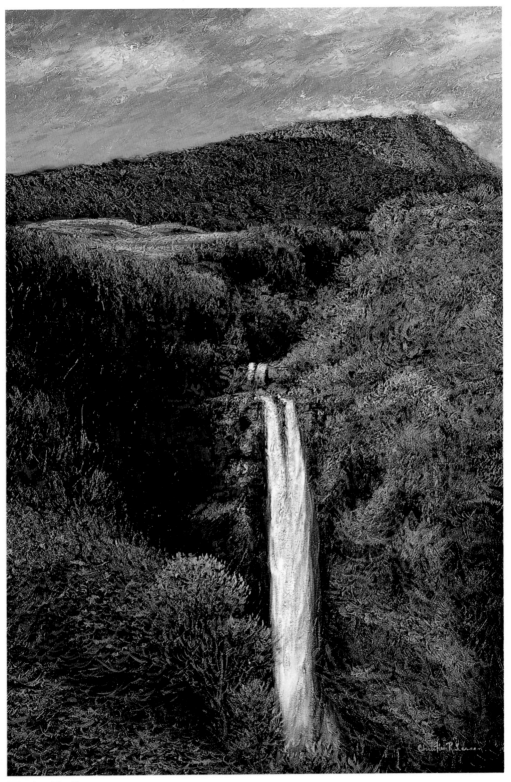

Twin Falls

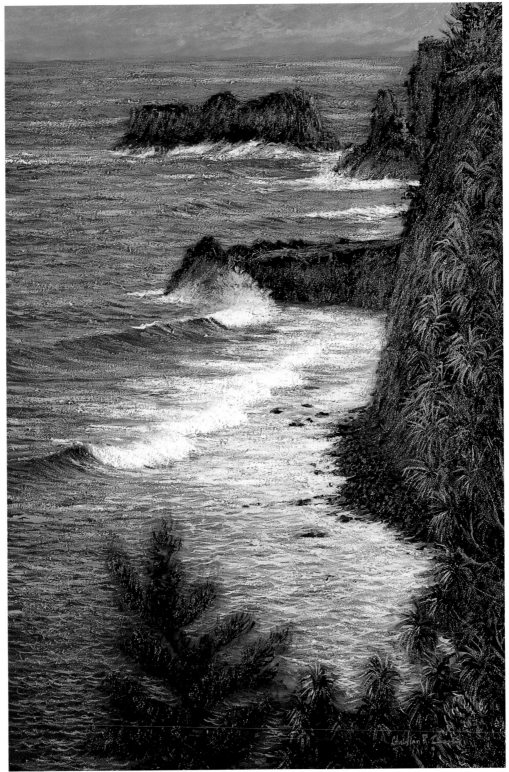

Hana Coast

No snow is there, nor ever heavy winter storm, nor rain, and Ocean is ever sending gusts of the clear-blowing west wind to bring coolness to man.

HOMER

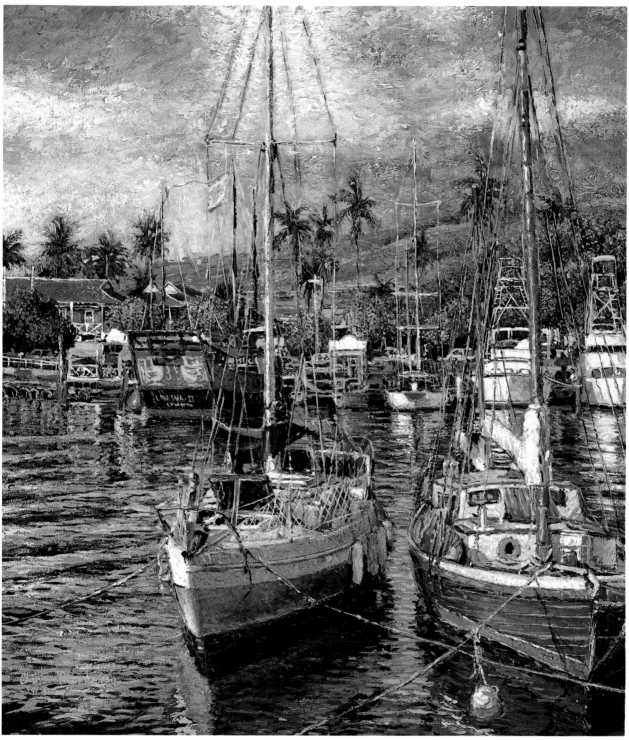

Impressions of Maui

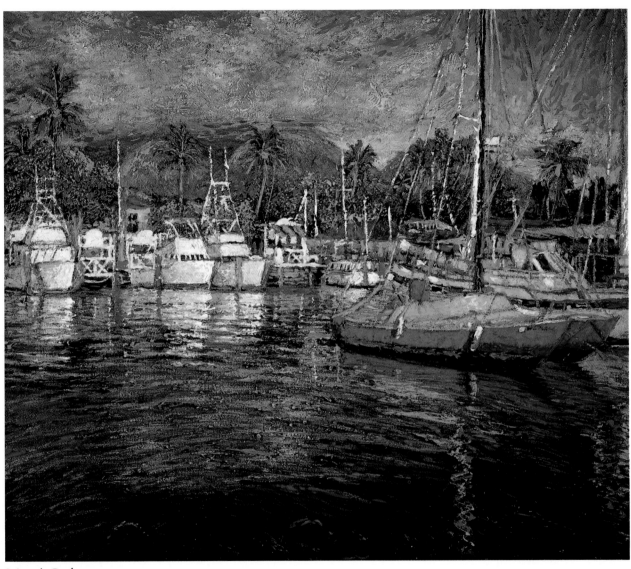

Maui Colors

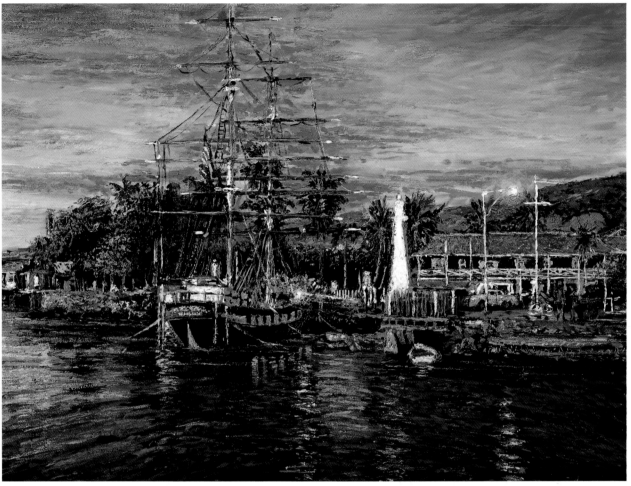

Lahaina Impressions

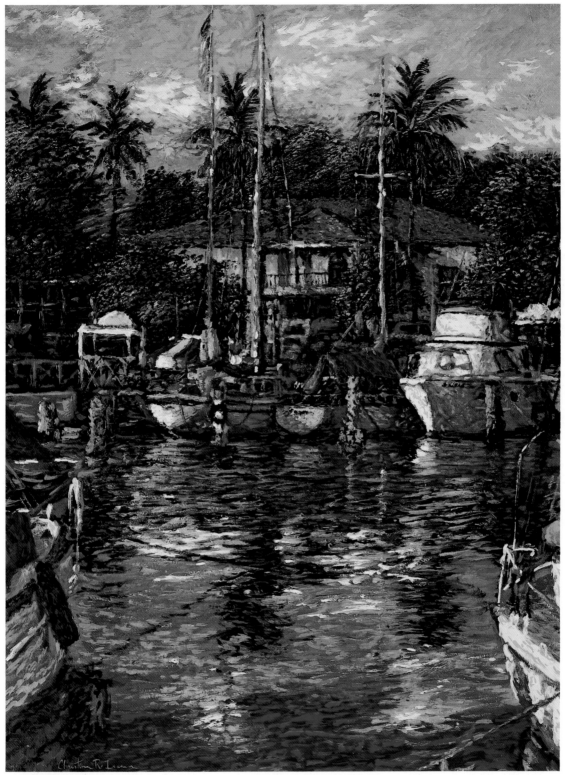

Lahaina Reflections

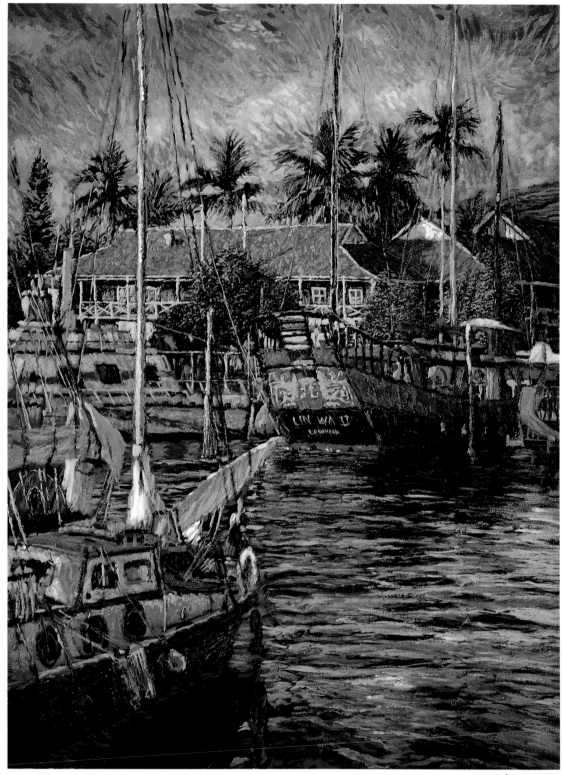

Lin Wa II

*Every child is an artist.
The problem is how to remain
an artist once he grows up.*

PABLO PICASSO

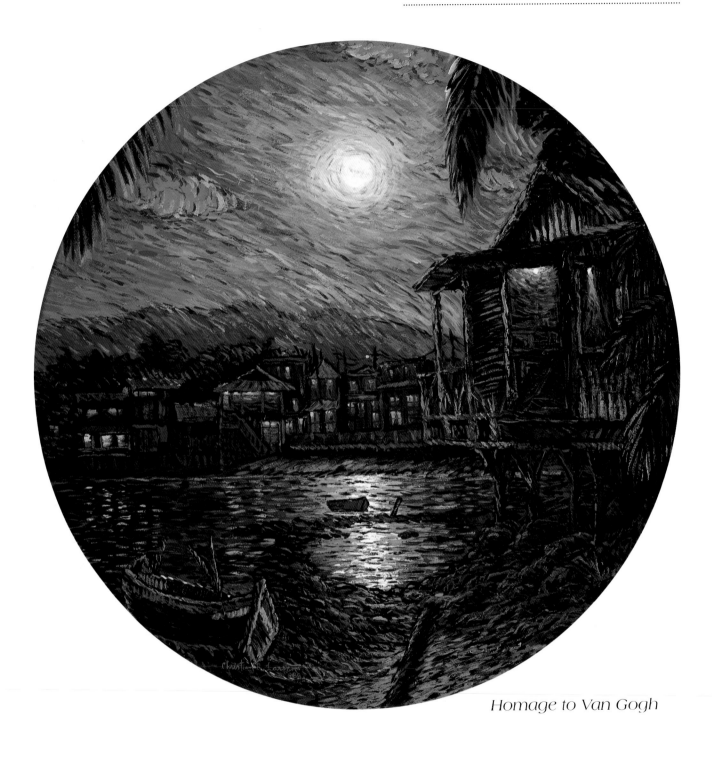

Homage to Van Gogh

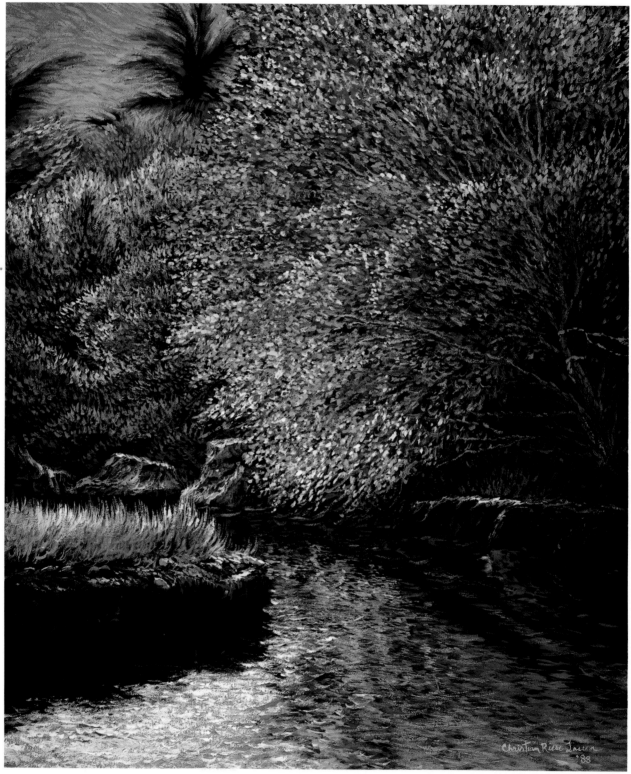

Maui Gardens

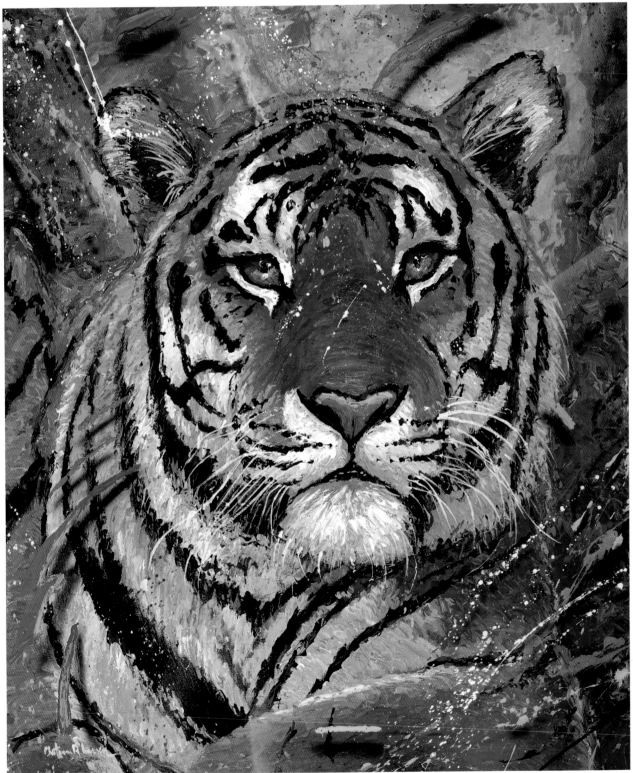

Tiger

Roll on, thou deep blue Ocean roll!

Ten thousand fleets sweep over thee in vain;

Man marks the earth with ruin, — his control

Stops with the shore; — upon the watery plain

The wrecks are all thy deed, nor doth remain

A shadow of man's ravage, save his own.

LORD BYRON

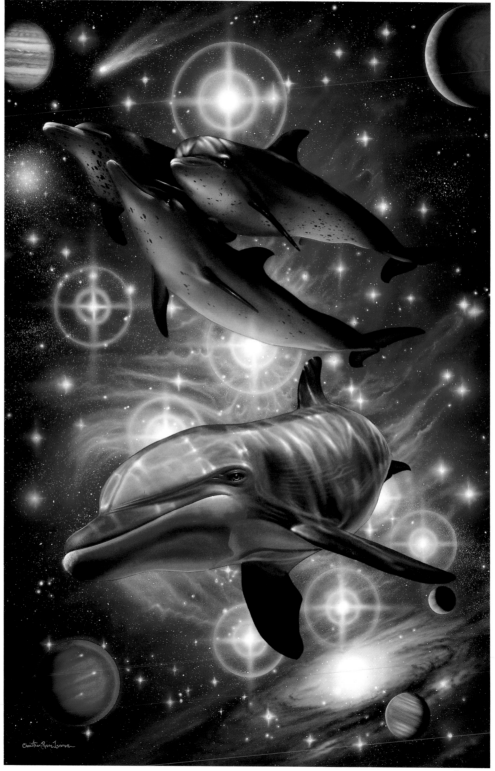

Infinity

SPORTS

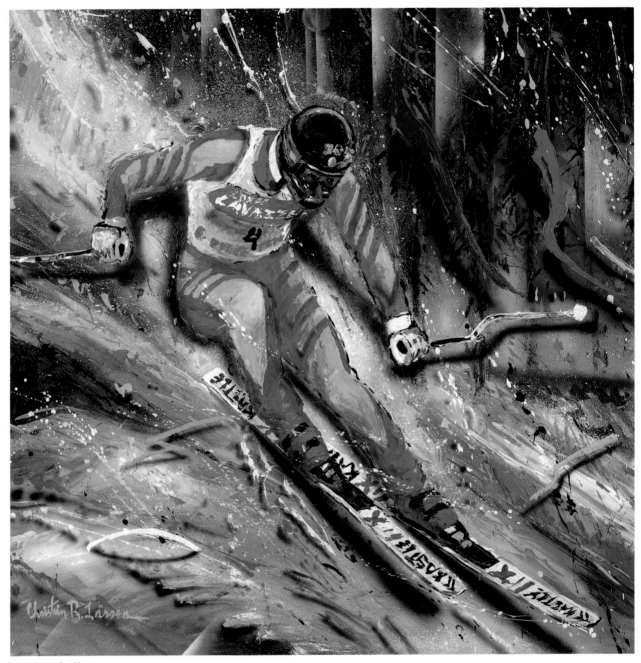

Downhill

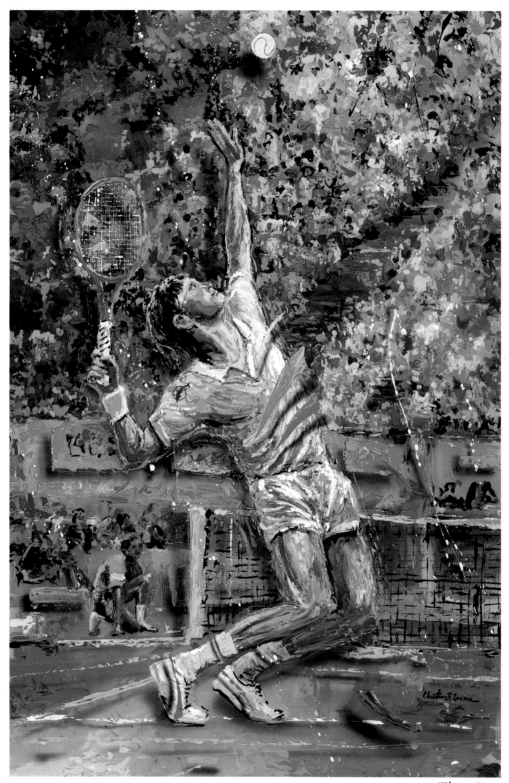

The Ace

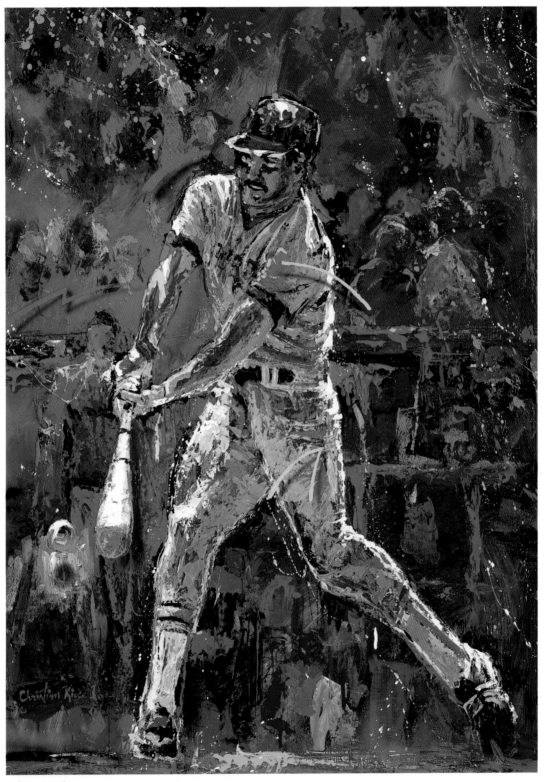

Line Drive

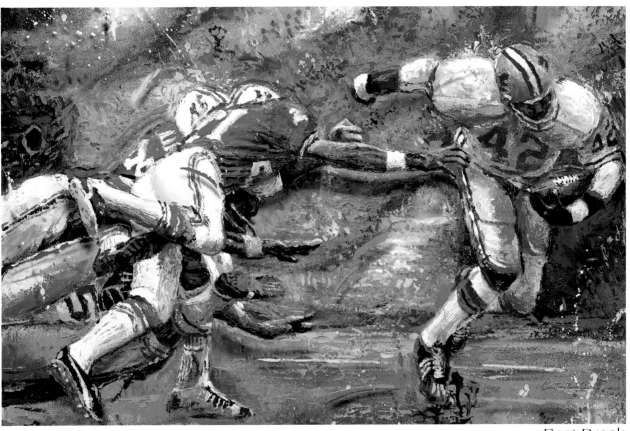

Fast Break

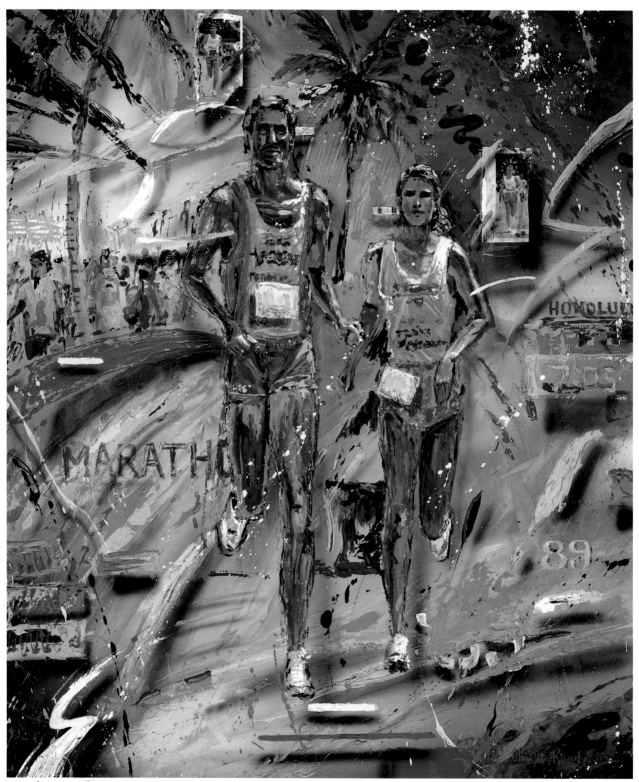

Endurance

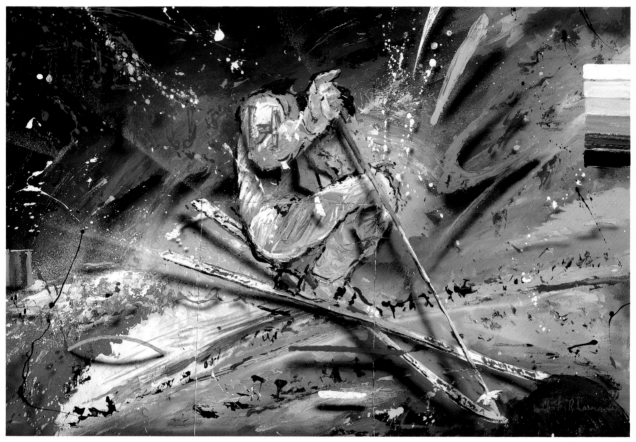

The Rush

Man is a long time coming.

Man will yet win.

Brother may yet line up with brother:

This old anvil laughs at many broken

hammers.

CARL SANDBURG

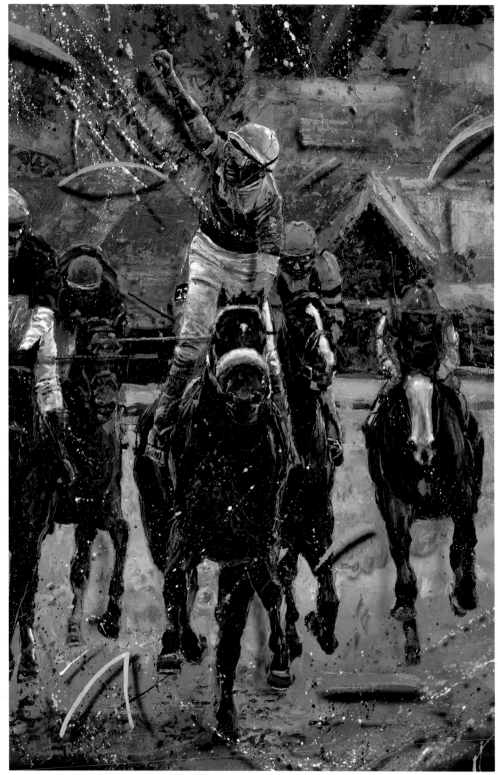

The Race

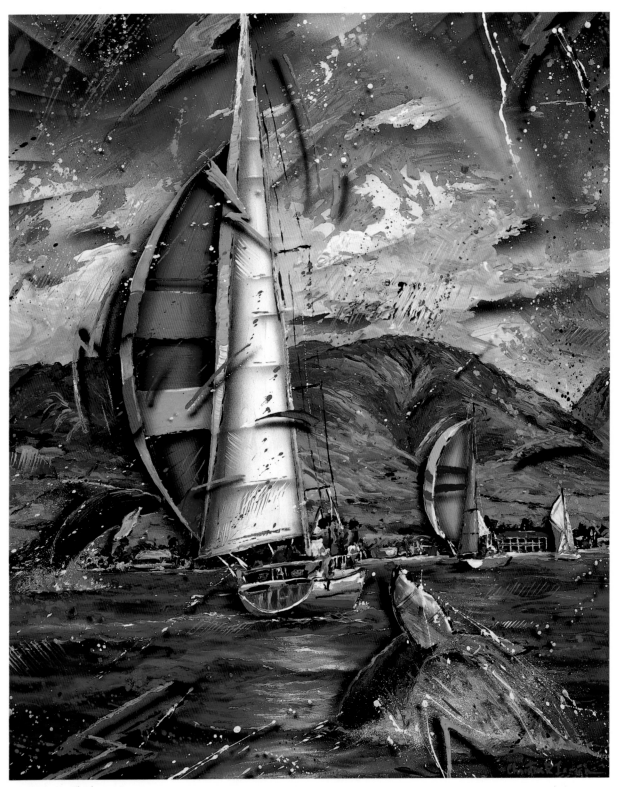

Maui Sailabrations

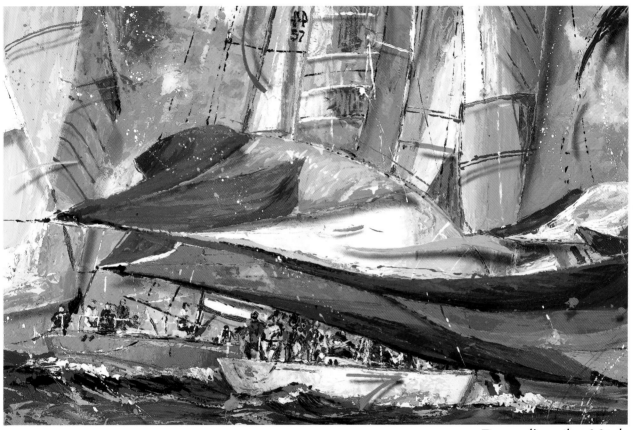

Rounding the Mark

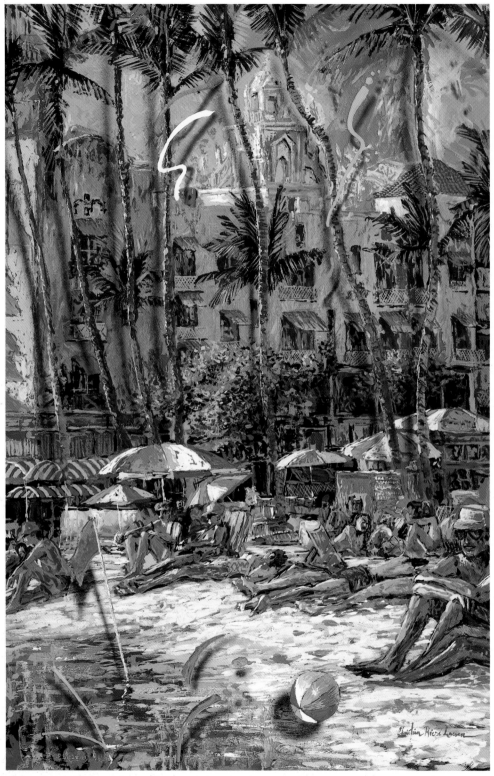

Sands of The Royal

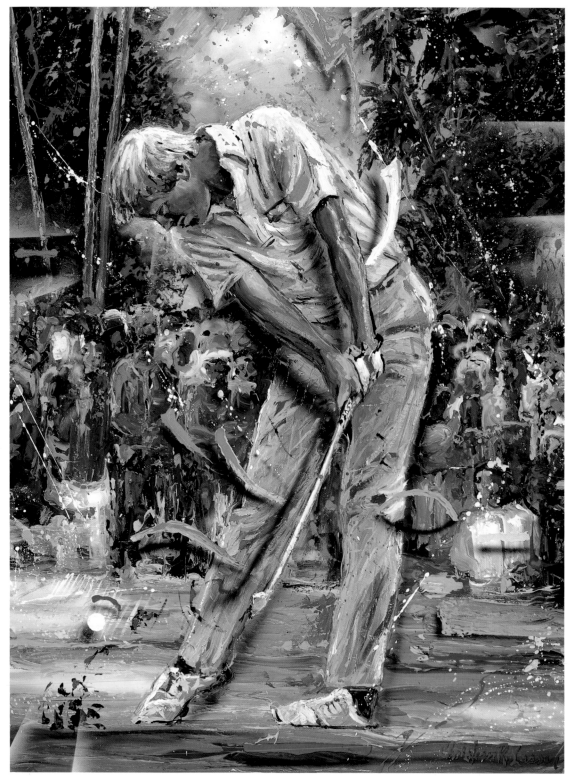

The Tournament

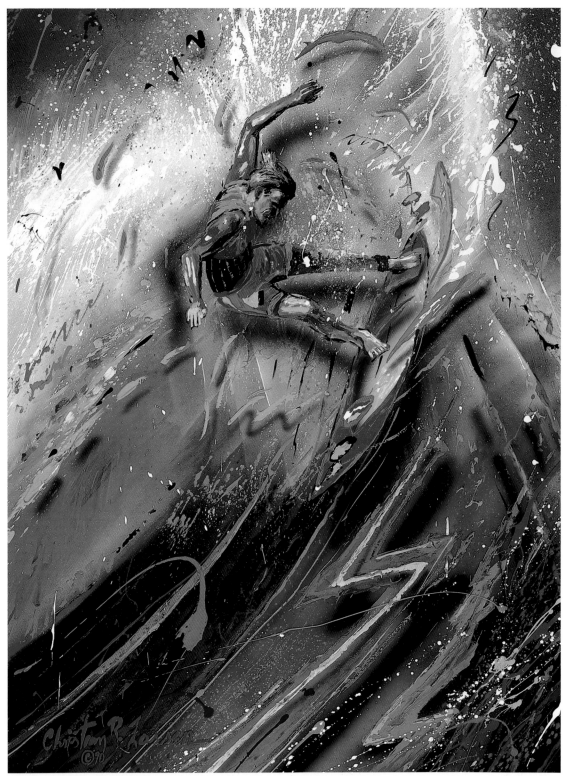

Triple Crown Surfer (dedicated to the memory of surfer Ronny Burns)

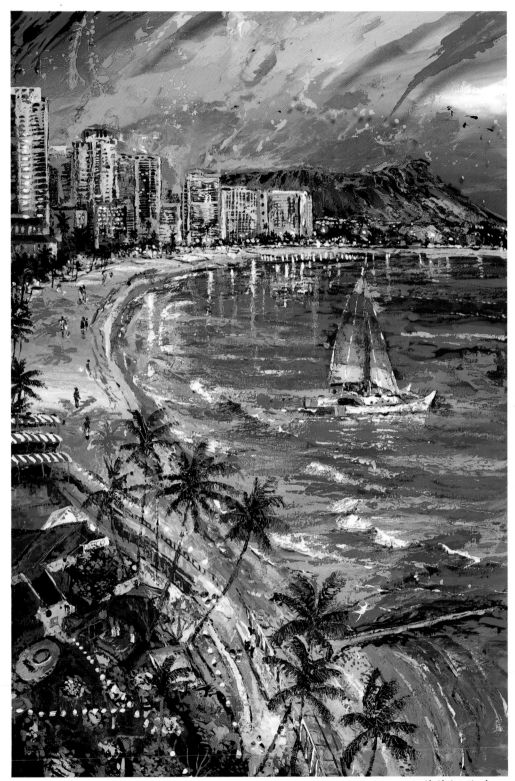

Waikiki Nights

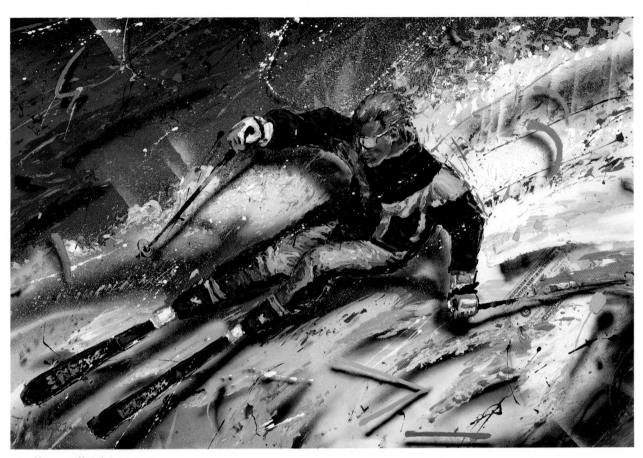

Dollar Bill Skier

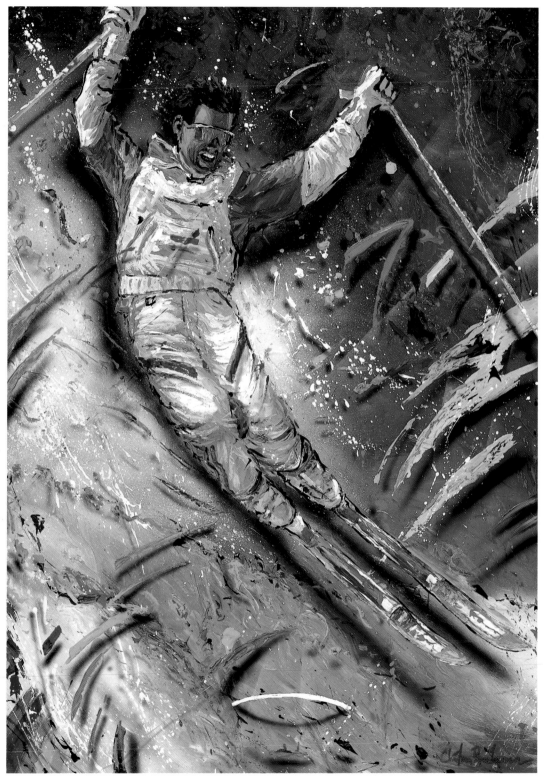

Freestyle

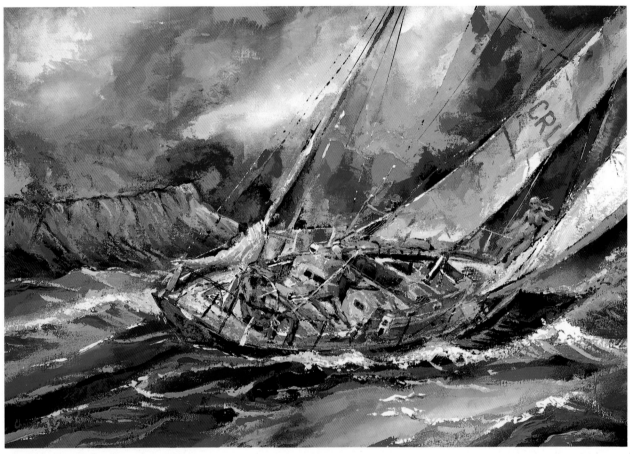

Windward Passage

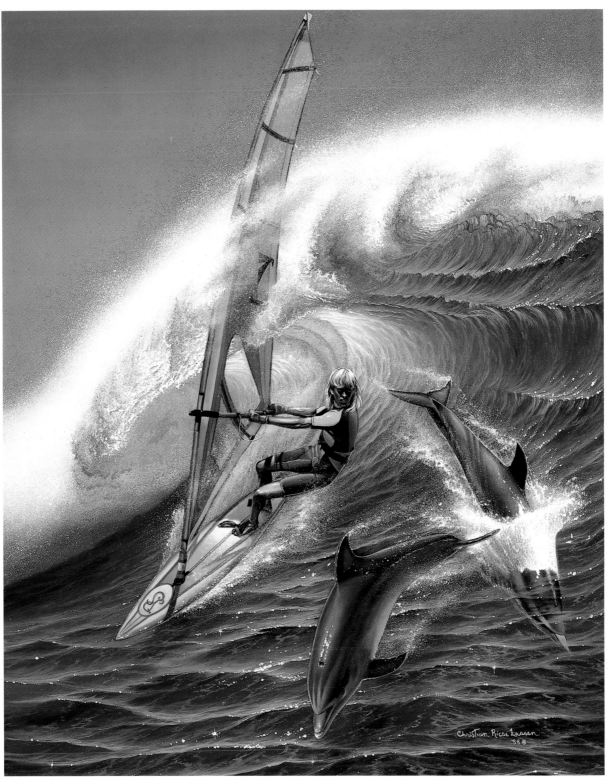

Windsurf